IMAGES
of America

MARIETTA
1833–2000

James B. Glover II

Rebecca Nash Paden

Joe McTyre

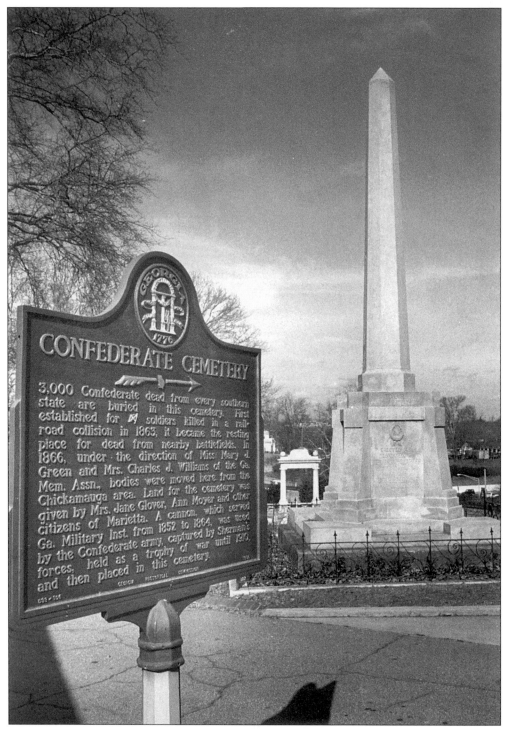

A monument honoring soldiers buried in the Marietta Confederate Cemetery stands near the entrance. (Photo by Joe McTyre.)

IMAGES
of America

MARIETTA
1833–2000

James Bolan Glover V, Joe McTyre,
and Rebecca Nash Paden

ARCADIA

Published by Arcadia Publishing,
an imprint of Tempus Publishing, Inc.
2 Cumberland Street
Charleston, SC 29401

Printed in Great Britain.

Library of Congress Catalog Card Number: Applied for.

For all general information contact Arcadia Publishing at:
Telephone 843-853-2070
Fax 843-853-0044
E-Mail sales@arcadiapublishing.com

For customer service and orders:
Toll-Free 1-888-313-2665

Visit us on the internet at http://www.arcadiaimages.com

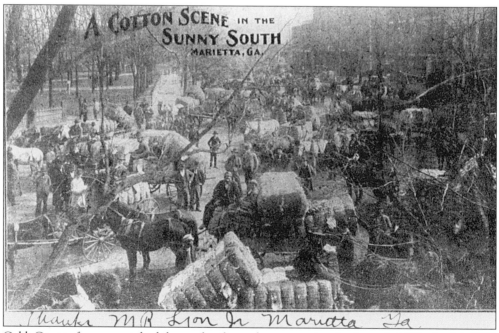

Cobb County farmers watched the market for peak cotton prices in the early 1900s. In this 1908
scene, farmers with their mules and farm wagons are ready to sell their cotton harvest in
downtown Marietta. (Carolyn Amburn postcard collection.)

CONTENTS

ACKNOWLEDGMENTS

The authors wish to thank the following for their invaluable assistance in assembling information, photographs and other materials for this book:

Daniel O. Cox, executive director, Marietta Museum of History
Bill Kinney, executive editor, *Marietta Daily Journal*
Carolyn McFatridge Crawford, director, Georgia Room, Cobb County Public Library
Dr. Thomas A. Scott
Dr. Philip L. Secrist
Russell D. King
Marietta Daily Journal

No history of Marietta or Cobb County would be possible today without the excellent account of the founding and early years of the area by Sarah Blackwell Gober Temple. She wrote *The First Hundred Years—A Short History of Cobb County, in Georgia* (1934).

 We also thank the many Marietta and Cobb County residents who allowed us to use their family photographs and records in the preparation of this book. Some of the pictures have photographers' credits with the captions because their work is documented. For those who contributed photographs we have not used, we are also grateful and hope to use them in a future edition.

James Bolan Glover V
Joe McTyre
Rebecca Nash Paden
August 1999

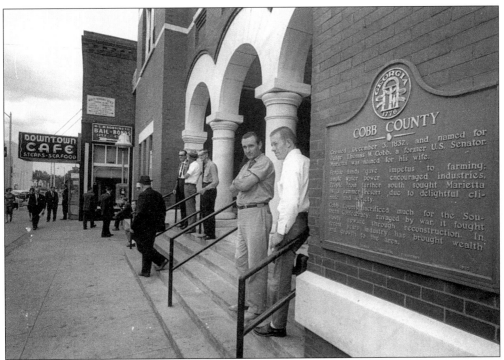

Many deals were struck on the steps outside Cobb Courthouse. This view taken in 1964, looking north toward the Downtown Cafe, shows the plaque on the building. (Photo by Joe McTyre.)

INTRODUCTION

Marietta, like its younger neighbor Atlanta, has experienced extreme contrasts of urban life: residential, business, and industrial development, military occupation, rebuilding, and unprecedented economic growth. For 165 years, the town has played an important part in the government and growth of the state of Georgia. This book gives an overview in words and pictures of Marietta's history from its establishment as the Cobb County seat of government in 1834 to its second turn of the century. The images range from drawings of Civil War-time Marietta to peaceful gatherings on the town square. While the book is divided into chapters depicting six distinct periods in the city's history, there are fewer images available from the early 1830s to the 1860s than other times. This volume contains 215 photographs, drawings, and maps, all gathered from private individuals, newspapers, and museums, most of which have not been published previously. *Marietta: 1833-2000* provides a distinct picture of a small southern town as it maintains its individuality in the midst of a large urban region.

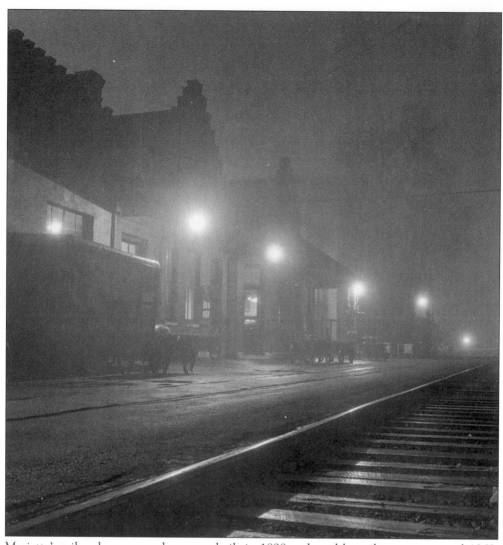

Marietta's railroad passenger depot was built in 1898 and used by rail passengers until 1969. The building now serves as the Marietta Welcome Center and Visitors Bureau. (Photo by Joe McTyre.)

One

BEGINNINGS

1832–1860

Long before European explorers came to Georgia in 1540, the Cherokee Indians occupied lands in north Georgia that now include Marietta and Cobb County. When the first white settlers began arriving in 1830, Native Americans lived in scattered farm communities and villages. Nine years later, only a few Cherokees remained after federal troops removed their tribe to Oklahoma for resettlement. The discovery of gold in North Georgia in 1828 and the demand for land brought much conflict between the white pioneers and Native Americans. The state of Georgia carved up the Cherokee Indian territory in 1832, establishing Cobb and nine other counties. White settlers, some already encroaching on the Cherokees' land, obtained lots in a state land lottery in 1832, dividing Cobb's allotted land into 40-acre gold lots and 160-acre land lots.

Although Cobb was never a large slave-holding county, the 381 slaves recorded in 1838, grew to about 3,500 in 1860. While the area produced little cotton, the 1850 Census records show grains, vegetables and fruits, tobacco, and wool were main crops[1]. Marietta was established as a village and the Cobb County seat in 1834, and chartered as a town in 1852. Probably named for the wife of Cobb County's namesake, Thomas Welch Cobb, Marietta's first buildings were crude log structures located on dirt streets near the present town square. A one-room log courthouse was built in 1834; two taverns, a drug store, and other businesses followed. Churches were established, including the Methodist in 1833, Presbyterian and Baptist in 1835, and Episcopal in 1842. Railroad construction attracted instant business activity and added commercial importance to Marietta[2]. The Western & Atlantic Railroad was completed through the area in 1845, providing a permanent boom and transforming the frontier village into a town with a population of 1,500. By the 1850s, a thriving Marietta became known throughout the state as a pleasant resort town with a park, many impressive houses, natural springs, and three hotels attracting summer visitors from the southern coastal areas. In 1851, the state established the Georgia Military Institute (GMI) on a 110-acre site near the town square. At its peak, GMI enrolled about 200 cadets who were educated and trained for military service. Among the most sought-after invitations for young Marietta girls were those for weekend dances at GMI, while townspeople regularly made short rides by buggy or horseback to the campus to watch afternoon parades. Other social activities included moonlight rides to Kennesaw Mountain, band concerts, and an occasional circus[3]. Prosperity continued and, in 1860, Marietta's population reached almost 2,700.

A large oak tree, seen standing on the grounds of the Henry Greene Cole cottage on Washington Avenue during the 1830s, became known as the Treaty Tree when Cherokee Indians and white residents met beneath its branches to negotiate issues. The tree was also a marker for an area where the Indians left their weapons when they went into the town of Marietta. Lightning killed the tree in the early 1900s. (Carolyn Amburn post card collection.)

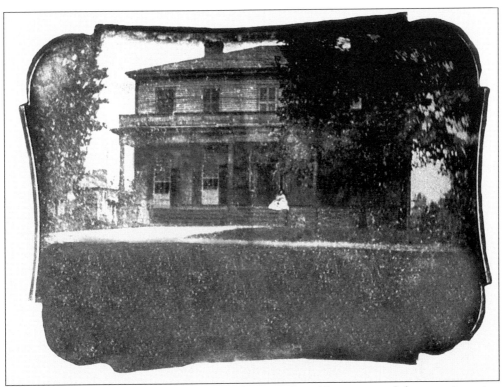

Kennesaw Hall, built in the 1840s by Charles J. McDonald, was one of the most imposing residences in the town. It was destroyed by federal troops when more than 100 houses and buildings burned in November 1864. (Charles M. Brown collection.)

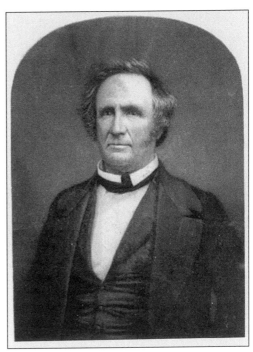

Georgia's 19th governor, Charles James McDonald, settled in Marietta in the 1840s. In 1822, he was named solicitor-general of the Flint Circuit in north Georgia and later circuit judge. Elected to the Georgia legislature as a representative in 1830, he later served two terms in the senate. McDonald was elected governor in 1839, serving four years, and was a state supreme court justice from 1855 to 1859. He died in 1860 and is buried in the St. James Cemetery. (Charles M. Brown collection.)

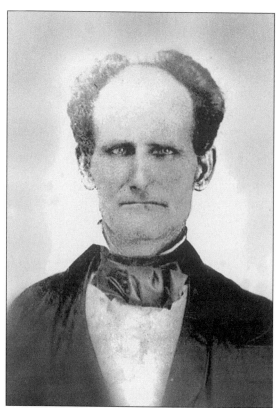

David Irwin, one of Marietta's pioneer citizens, came from Brooks County in 1838 and built Oakton about the same year. Born in 1807, he was a highly regarded lawyer and the first judge (1851–1855) of the Blue Ridge circuit in north Georgia. Irwin died in 1885. (Julia Yates collection.)

Oakton, built by Judge David Irwin in the late 1830s on Kennesaw Avenue, was originally a four-room dwelling. The house's third owner, John N. Wilder of Savannah, bought Oakton in 1852 as a summer residence for his family. He hired a Scottish gardener who moved to Marietta to design the outstanding boxwood gardens still remaining today. In 1864, the house was Confederate General W.W. Loring's headquarters. Oakton is now owned by the Goodman family. (Robert M. Goodman Collection.)

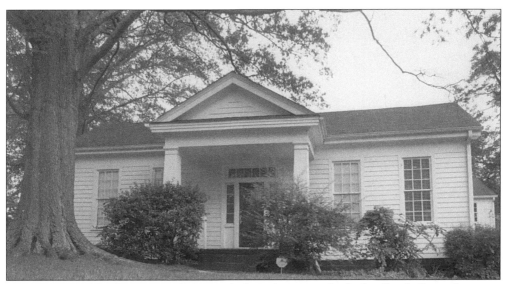

Dr. Martin G. Slaughter, one of Marietta's first physicians, built the Greek Revival cottage facing Atlanta (then Decatur) Street about 1840. Originally the house had a central hall and two rooms on each side. Dr. Slaughter sold part of the front grounds and turned the house to face Frasier Street. (Photo by Joe McTyre.)

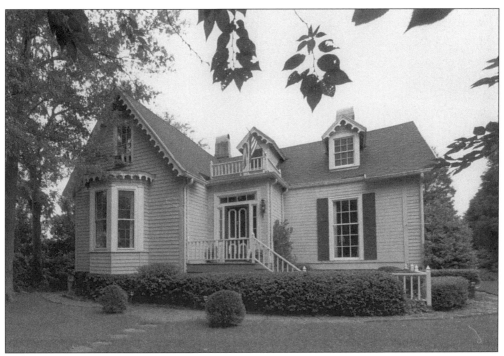

N.P. Gignilliat was among the first to build frame houses in Marietta in the 1840s, including the Gignilliat-Griffin-Gilbert house, a two-story plantation plain style structure shown here on Kennesaw Avenue. The house is one of Marietta's oldest dwellings. Like several other antebellum houses, repairs and alterations to the house in the late 1800s produced a Victorian appearance, but many original features were preserved. (Photo by Joe McTyre.)

William Gibbs McAdoo Jr. (1863–1941), shown with young women during a Marietta visit in 1920, was born at Melora when the McAdoo family fled the Union occupation of Knoxville, taking refuge in the Powder Springs Road house. McAdoo served as U.S. Treasury secretary under President Woodrow Wilson and married Wilson's daughter in 1912. McAdoo headed the Democratic Party in 1924, the same year he made an unsuccessful presidential bid. (Vanishing Georgia collection, Ga. Dept. of Archives and History.)

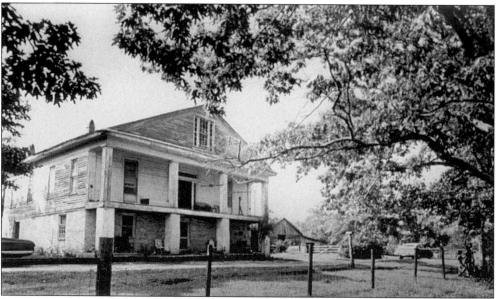

Melora, also known as the McAdoo House, was probably built in the late 1840s by Richard Joyner on his 40-acre plantation on Powder Springs Road. The two-story Greek Revival raised cottage has four Doric columns with a portico. Walthall Robertson Joyner, mayor of Atlanta from 1906 to 1908, was born in the house in 1854. Although situated in the middle of Union and Confederate fortifications, the house survived the Civil War with only slight damage. After the McAdoos, other owners were the Oatman, Lawrence, and Walker families. In 1998, the Cobb Preservation Foundation acquired the house and 1.6 acres of property, almost surrounded by modern development. The foundation is marketing the house through its revolving fund with covenants to ensure its preservation. (Marietta Daily Journal collection.)

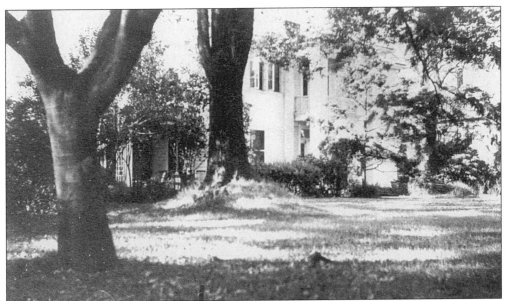

The Warren Benson house, a handsome two-story antebellum frame dwelling, was originally located on Whitlock Avenue. The house was moved to Trammel Street in the 1970s when a local bank acquired the property and built a commercial building on the busy corner of Whitlock and the Highway 120 Loop. (Regina Goldsworthy Stott collection.)

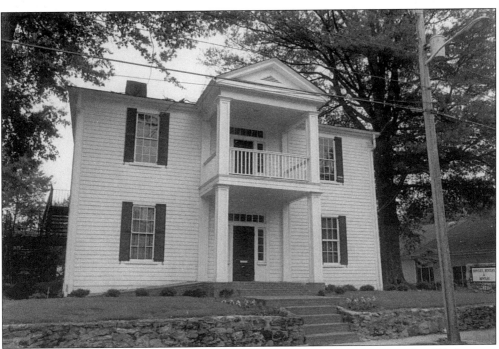

Cobb County's second courthouse, built in 1838 facing the square, was moved to Washington Ave. in 1853 when a new two-story brick court building was completed. The historic frame structure surrounded by columns was used as a dwelling after its days as the courthouse and is now a law office. (Photo by Joe McTyre.)

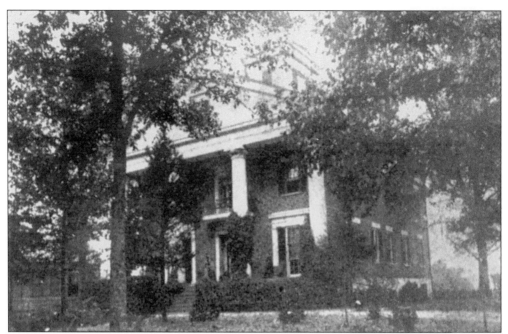

Col. Archibald Howell oversaw the building of his Greek Revival mansion on Kennesaw Avenue in 1848. Handmade bricks formed the 28-inch-thick walls and granite hauled from Stone Mountain by oxcart was used in the foundation. The impressive Doric columns are among the largest in the area. Union Gen. H.M. Judah used the house as his headquarters during the occupation of Marietta in 1864. Howell sold his house in the 1880s and moved his family to a Victorian residence across the street, while a group of Marietta citizens established Harwood Seminary, a girls school, in the house. (Julia Yates collection)

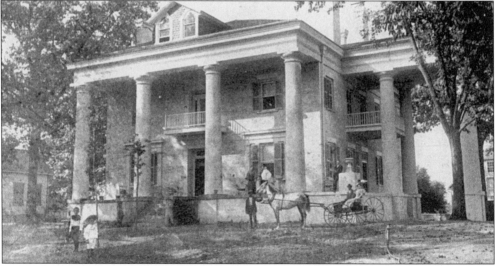

Judge William M. Sessions bought the Archibald Howell House and made extensive renovations in the 1890s. The photograph, dated 1898, shows from left to right: (in yard) Archibald D. Sessions, and Lee M. Sessions; (in wagon) Moultrie M. Sessions, and Jane D. Sessions; (on porch) Susie Sessions, Sallie Sessions, and Lucille Sessions Cappes. (Robert M. Sessions-Ella Kappas Edwards collection.)

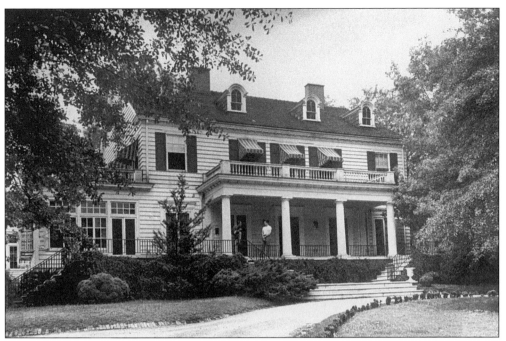

Edward Denmead, one of Marietta's pioneer residents, built Ivy Grove in 1843. The two-story country estate originally sat on 1,800 acres on the present Cherokee Street. During the Civil War, Union cavalry heavily damaged the place during occupation of the house. As a result of the war, Denmead lost most of his fortune and sold the house and property in 1874. Ivy Grove was also the home of James V. Carmichael, an unsuccessful candidate for Georgia governor in 1946 and Bell Aircraft Corporation's general counsel. (Bill Kinney collection.)

The Denmead Building, built about 1850 by Edward Denmead on Mill Street, is one of two buildings still standing that survived Civil War devastation in downtown Marietta. (Photograph by Joe McTyre.)

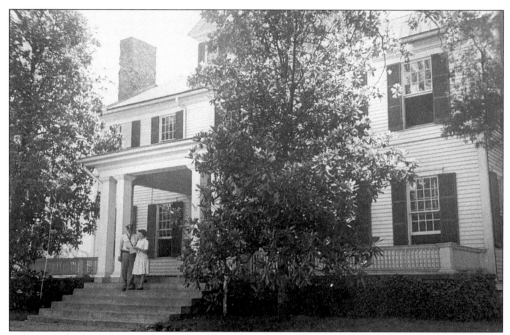

Cottage Hill, built about 1847, was acquired by Josiah Sibley of Augusta in 1862 as a summer home for his family. During the Civil War, shells and cannonballs took their toll on the house and Confederate troops erected fortifications in the yard. Sibley's granddaughters were forced to leave when their property was condemned by the federal government during World War II. The house, although much altered, was for many years the Officers Club for Dobbins Air Reserve Base. (James B. Glover V collection.)

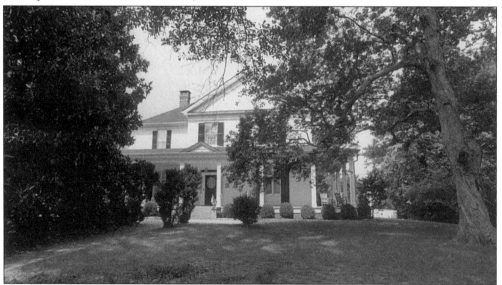

Elwood was built before the Civil War by John Radford Winters who came to Marietta in 1833. Other owners were the Pomeroy, Dobbs, and Daniell families. After falling into disrepair, the house was extensively modified in the 1990s by the present owners. In a picturesque setting among shady old trees, Elwood retains several of its original features including a smokehouse, now used as a garden house. (Photo by Joe McTyre.)

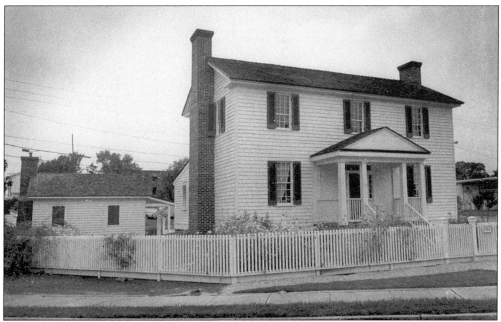

One of the earliest houses built in Marietta is the Root House, constructed on Church Street about 1845 by William Root, the town's first druggist. Root was born in Philadelphia in 1815 and came to Marietta in 1839. After his death in 1891, the house was moved back from Church Street and turned to face Lemon Street. The Greek Revival dwelling stands on the Marietta 120 Loop in its third location. Owned by Cobb Landmarks and Historical Society, the building is a house museum open Tuesday through Saturday, from 11 a.m. until 4 p.m., with an admission charge. (Photograph by Joe McTyre.)

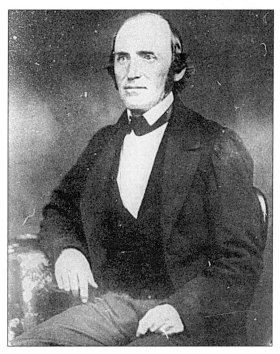

William K. Root, born in 1815 in Philadelphia, arrived in Marietta in 1838 and opened the first pharmacy in the young community. He was one of the founders of St. James Episcopal Church in 1842. Root served two terms as county coroner, beginning in 1883. He died in 1891 and is buried in the Marietta City Cemetery. (Cobb Landmarks and Historical Society collection.)

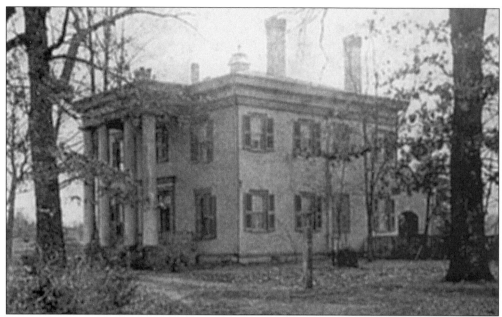

Tranquilla, a stately Greek Revival house on Kennesaw Avenue, was built in 1849 by Andrew Jackson Hansell, a state representative and senator from Cobb County. During the Civil War, Hansell served as Georgia's adjutant general, leaving his wife, children, and servants alone in the house. Both Confederate and Union officers occupied Tranquilla in 1864. Later, Caroline Hansell stood down a group of intruders who demanded she leave while they looted the house. Instead, she aimed a small derringer at the crowd and threatened to shoot anyone entering her home. The intruders left, sparing Tranquilla. After the war, the Hansell family sold the house and moved to Roswell. In 1872, George Camp acquired Tranquilla and it remained in the same family until 1996. (Marietta Museum of History collection.)

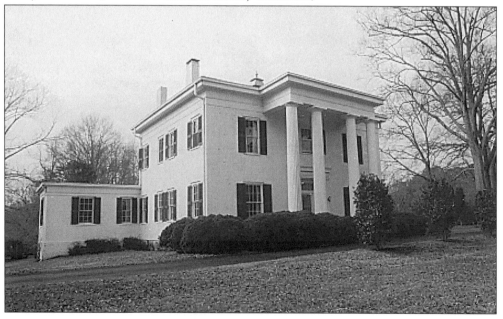

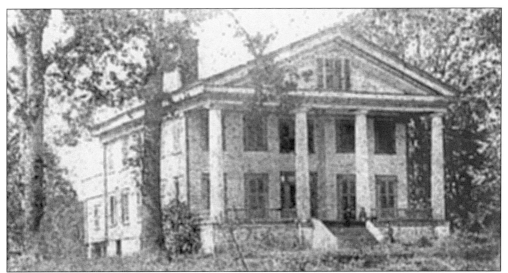

Charleston planter John Heyward Glover Jr. built Bushy Park, a Greek Revival plantation house, on his 3,000-acre property in 1848. The house had 17 rooms and many outbuildings, including a stone kitchen which still exists. Heart-pine floors and hand-hewn beams are featured in the house. William King and his servants occupied the mansion during the Civil War battles in 1864. The house was also used as a federal hospital. A later owner was Robert Garrison, president of the Arrow Shirt Company. Situated on 13 remaining acres of the plantation, it is now home to the 1848 House, a local restaurant. (Marietta Museum of History collection.)

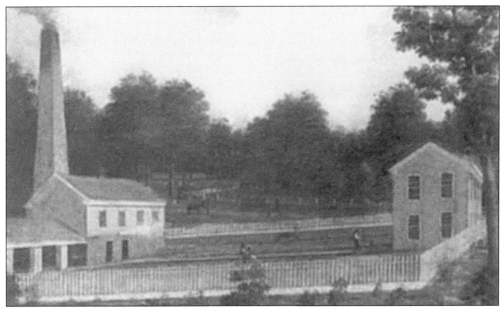

Glover's Tannery was built in 1848 by John Heyward Glover Jr. on his Bushy Park Plantation property near the present intersection of Atlanta and Gramling Streets. Wet bark was used for fuel to prepare more than 7,000 hides annually. Just before the Civil War, Mrs. Glover deeded the tannery to William J. Russell, Senator Richard B. Russell's grandfather. The building was destroyed during the Federal occupation of Marietta in 1864. The tannery's 85-foot smokestack stood until the early 1950s. (James B. Glover V collection.)

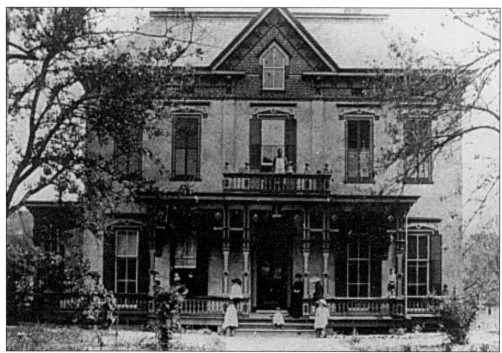

John Heyward Glover Jr. built a house on Whitlock Avenue in 1851. Glover's wife, Jane, urged the move because Bushy Park was too far removed from the town's social life. The house was set on fire and, according to family records, Federal soldiers also stabled horses in the parlor and stole family silver and portraits. Although the house's original design was Greek Revival, it was rebuilt in the Italianate style after a fire in the 1880s. (James B. Glover V collection.)

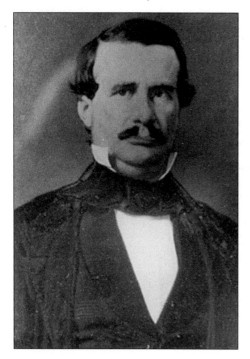

John Heyward Glover Jr. came to Marietta in 1847 from his family's South Carolina plantations to begin industrial development in a more temperate climate. In 1852, he donated the land for the downtown park, named Glover Park in his honor, and was elected Marietta's first mayor. (James B. Glover V collection.)

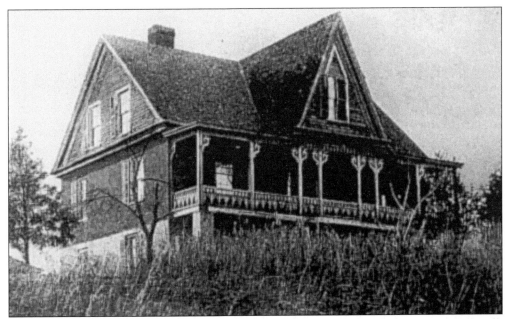

In the mid-1800s, the area northwest of the Marietta square was known as Campbell Hill. Original landowner John McCarter gave part of his 40 acres to his daughter who married John G. Campbell. The young couple built a two-story house in 1852 and lived there until 1864, when the Battle of Kennesaw Mountain was fought nearby. When the Campbells returned, only the house walls were standing and the property was surrounded by trenches. The Campbells restored the house and added a third floor. In 1938, Mr. and Mrs. Robert C. Suhr of Cleveland, Ohio, bought the house and 22 acres and lived there until 1952. (Lila McNeel Parks collection.)

St. Joseph's Catholic Parish was officially established in 1952, but Marietta's small Catholic community met as a mission much earlier. In 1952, the parish bought the Campbell Hill house and six acres from the Suhr family. The antebellum structure has been used as a parish rectory and meeting center for priests and parishioners since that time. After acquiring six more acres nearby, St. Joseph's built a school and a sanctuary. This view of the parish house today shows the east entrance. (Photograph by Joe McTyre.)

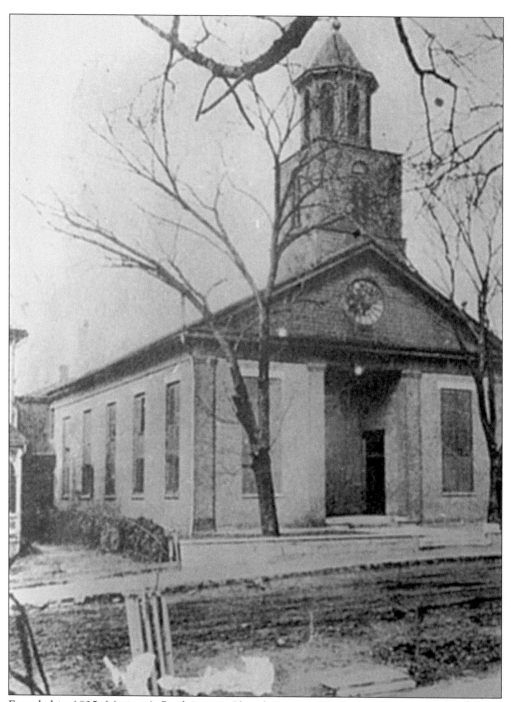

Founded in 1835, Marietta's Presbyterian Church is one of the oldest in the community and numbers among its charter members many town pioneers and leaders. In 1854, the congregation of 100 built a 450-seat Greek Revival sanctuary. Ten years later, the building was used as a hospital for wounded federal soldiers during the Civil War. In 1910, the U.S. government paid the church $2,400 in reparations for wartime damages. (First Presbyterian Church collection.)

Dr. Edward Porter Palmer, pastor of the Marietta Presbyterian Church during the Civil War, served as a Confederate Army chaplain on two occasions. After the federal army captured the town in July 1864, he joined General Johnston's army as a Confederate army chaplain and served until the war's end. Church services resumed after a year's interruption when he returned to his duties as pastor in July 1865. (First Presbyterian Church collection.)

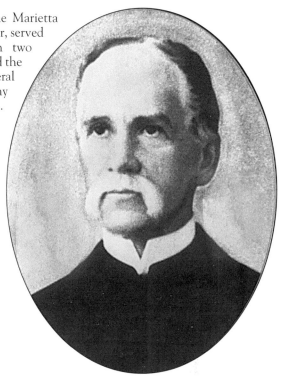

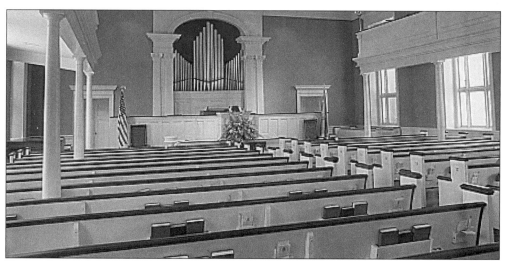

The First Presbyterian Church sanctuary has the original heart-of-pine floors, slave gallery, and wall paint color, a "buttermilk wash," concocted in the 1850s by mixing buttermilk and Georgia red clay. It is the oldest sanctuary still in use in Cobb County. (Photo by Joe McTyre.)

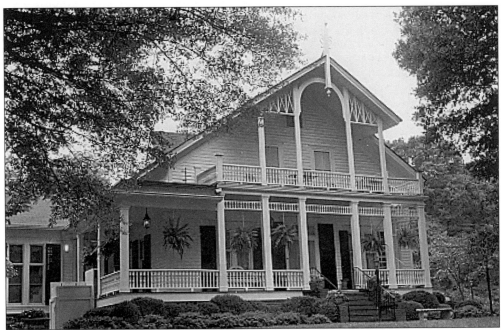

In 1852, Mr. and Mrs. Newton House built the two-story square-columned house with hand-made nails, wooden pegs, and 20-inch rock wall underpinning. The Edward Myers family, the house's second owners, named the house Fair Oaks because of two oak trees, one with a cannon ball embedded in its trunk, flanking the front steps. Unofficial sources claim the house was Gen. Joseph E. Johnston's headquarters during the Battle of Kennesaw Mountain. In the 1920s, the Benson family acquired the house and, 40 years later, donated their home and three acres to the Marietta Council of Garden Clubs Incorporated for a Garden Center. (Photo by Joe McTyre.)

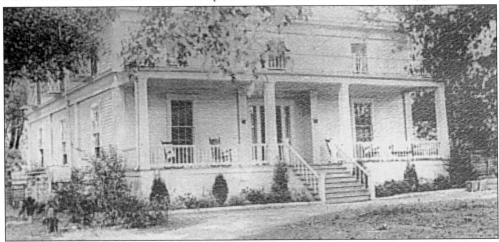

Built in 1846, the Gignilliat-Hutcheson house shown here stood in a grove of stately chestnut trees near the railroad and St. James Church. It was possibly spared from destruction during the Civil War because a widow and her crippled son were the occupants. The eulogy for slain Confederate General Leonidas Polk was read on the grounds. The Gignilliat family of Darien purchased the house in 1866 for $5,000 and owned it for many years. The last owner, Robert Hutcheson, sold it to a lumber company which demolished it and built a lumber yard on the site. (Marietta Museum of History.)

The Kennesaw House was originally a breakfast house built between 1845 and 1855 in downtown Marietta near the railroad. In 1855, Dix Fletcher bought the property and built a four-story hotel around the original building, naming it the Fletcher House. Union spies spent the night there in 1862 before the Andrews Raid. The incident led to a famous railroad chase, and the capture of James Andrews and several co-conspirators who were hanged. The 22 men involved were the first recipients of the Congressional Medal of Honor. In 1863, the building was used as a Confederate hospital and briefly as General William T. Sherman's headquarters in 1864. The top floor, burned by federal troops, was removed and the structure was repaired after the war. The hotel reopened in 1867 as the Kennesaw House. Today, the building houses the Marietta Museum of History and several business offices. (Photograph by Joe McTyre.)

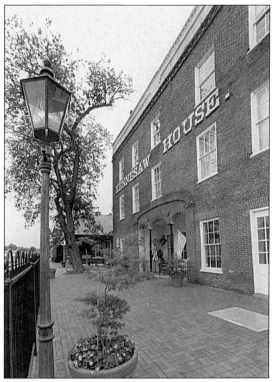

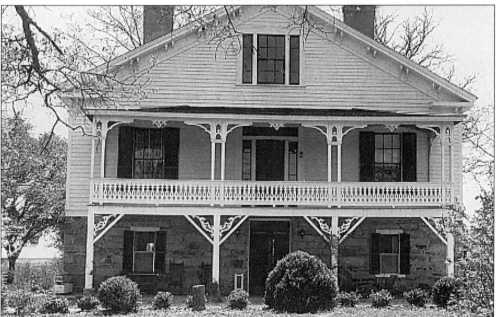

Rockford, now known as the Manning House, was built by Dr. Sidney Smith before the Civil War. Confederate Gen. William J. Hardee had his headquarters in the house in 1864 during the battles in Cobb County. Judge James T. Manning, solicitor general of the Blue Ridge judicial circuit and a member of the Georgia House of Representatives from 1933 to 1937, and family have been longtime owners. (Photograph by Joe McTyre.)

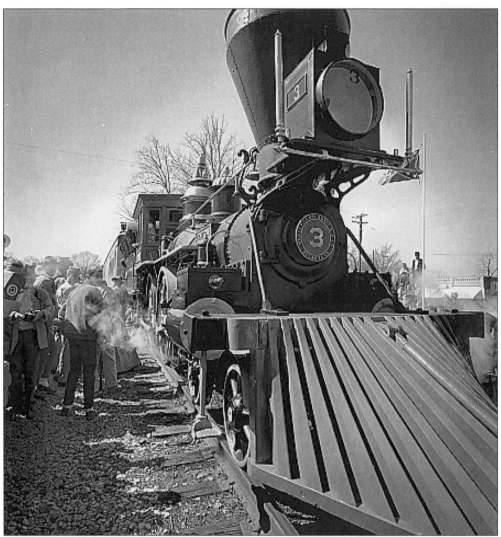

Famed locomotive "The General" left Marietta in 1962 for its new home in Kennesaw ("Big Shanty," as the town was known in 1862 when the Andrews Raiders stole the Confederate train while the crew stopped for breakfast). James Andrews and 21 Federal soldiers, captured by the train's conductor and Confederate soldiers, were taken to Atlanta for trial. After their conviction, Andrews and seven Federal soldiers were hanged, eight escaped, and six were later exchanged for Southern prisoners of war. The raiders were the first recipients of the Congressional Medal of Honor. (Photograph by Joe McTyre.)

Two

CIVIL WAR

1861–1865

After Georgia seceded from the Union in January 1861, most Marietta men left to join the Confederate army. Women and children provided food and supplies for wounded southern soldiers and refugees, while men too old to fight formed a home guard unit. The town's churches donated their bells to the Confederacy to be melted down for ammunition. Like others all over the South, Marietta families waited anxiously for news of casualties.

One event that brought the war close to home was the Andrews Raid in April 1862, when the Confederate locomotive "General" was commandeered by 22 Union spies. The group boarded the train in Marietta after spending the night at local hotels. While the crew and passengers stopped for breakfast, the raiders headed north in the locomotive and three boxcars. Andrews and his fellow conspirators were caught before they carried out a plan to destroy railroad tracks and bridges between Cobb County and Chattanooga.

Through the war years, GMI cadets gradually left school to join the army. By May of 1864, the younger students formed a battalion which served as a provost guard unit in Marietta before Sherman's forces arrived [4]. As the war dragged on, rumors of impending federal raids prompted most Mariettans to leave their homes as refugees. When the fighting began near the town in June 1864, very few families remained [5]. Formerly a peaceful village, Marietta was now a large depot, filled with troops and wagon trains carrying supplies for the Confederates. After the bloody battles of Kennesaw Mountain, Cheatham Hill, and Kolb's Farm nearby, citizens nursed wounded soldiers in homes and stores. The Confederate Army of Tennessee under General Joseph E. Johnston evacuated Marietta on July 3, 1864, and Union Gen. William T. Sherman and his army occupied the town. The next day, a Marietta plantation owner wrote in his diary there were "few acquaintances to be found." [6]

Under federal occupation, life went on but citizens were confined to town with limited activities under martial law. Churches and houses were requisitioned as hospitals for wounded Union soldiers. At St. James, the Church's rector and his assistant were arrested and banished for refusing to pray for President Abraham Lincoln. Union troops looted most of the town's homes and businesses and stole anything edible [7]. When federal troops left Marietta in November 1864, they destroyed the railroad and set fire to the courthouse, the GMI campus, mills, and tanneries. Other buildings and houses quickly added to the conflagration and one historian described the town as "a blackened ruin" with more than 100 structures lost [8]. After the South surrendered in 1865, Confederate soldiers straggled back to find widespread destruction by Federal troops and guerrilla bands of deserters from both armies. Until the railroad tracks were hastily repaired late that year, food and communications were in short supply [9].

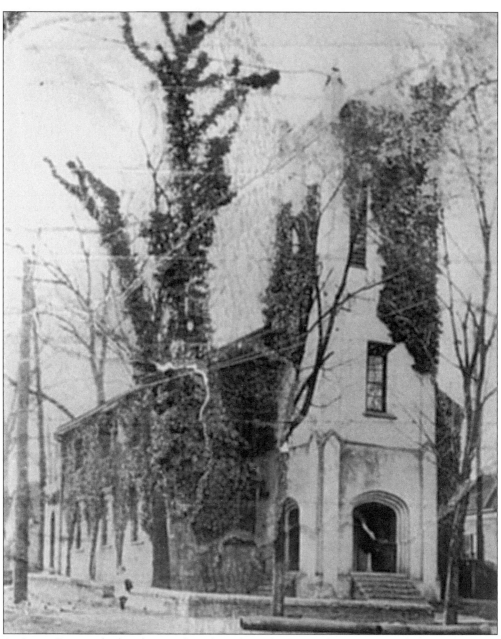

St. James Episcopal Church contributed much to the life of the Marietta community from its founding in 1842. In 1862, the church bell was donated to the Confederacy for material to make cannons. The church sanctuary was ravaged and used as a Federal hospital in 1864 and St. James' rector, the Rev. Samuel Benedict, and his assistant were banished from Marietta for refusing to lead prayers for President Lincoln. When parishioners failed to say "amen" after the prayers offered by the new rector, a company of Federal soldiers was ordered to church to say the "amen." The sanctuary escaped Sherman's fires but was ironically destroyed in an electrical fire in 1964. A new sanctuary building was dedicated in 1966. The church's bell tower has the only English change ringing bells in Georgia. (Floy Hunt Hodges collection.)

The original organ at St. James Episcopal Church was purchased in 1860 by the ladies of St. James who raised money by holding concerts and ice cream socials. The tracker pipe organ was manufactured by the E. & G.G. Hook Company of Boston. In 1864, Federal troops threw the organ out onto the street but a church member salvaged it. The instrument was repaired and returned after the war. It is still in use today in the Lawrence Chapel. (Photograph by Joe McTyre.)

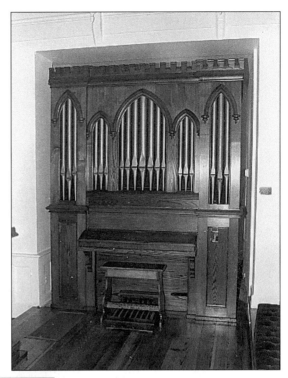

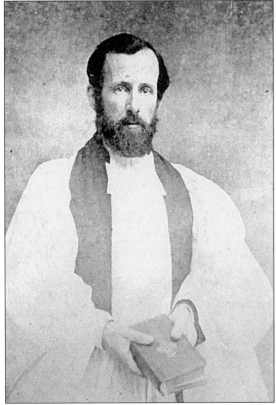

The Rev. Samuel Benedict was rector of St. James Church during the Civil War. A native of Connecticut, he was sympathetic to the Confederate cause and, while Marietta was occupied by Federal troops, refused to say prayers for President Abraham Lincoln. He and his assistant, the Rev. J.J. Hunt, were arrested, held in a Marietta Hotel room, and then banished for disloyalty. Reverend Benedict went to Canada and returned to St. James after the war. (Marietta Museum of History Collection.)

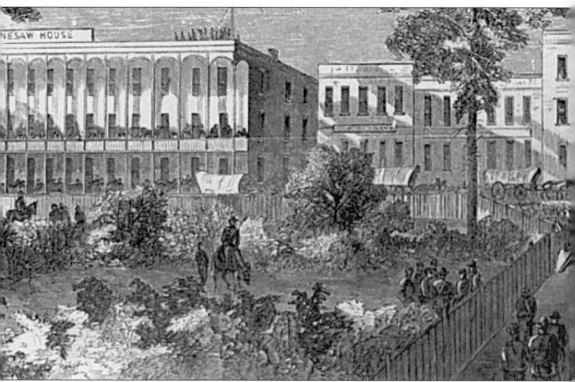

Harper's Weekly, a Civil War-era newspaper, entitled this drawing of wartime Marietta "View of Public Square, Marietta, Georgia" in 1864. The artist, Theodore Davis, misnamed the Marietta Hotel as the Kennesaw House. One account of Gen. William T. Sherman's final visit to

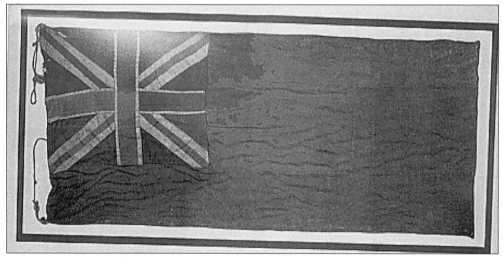

A British flag, pictured above, was stitched by a Marietta woman as General Sherman's troops invaded Marietta in July 1864. Anne Couper Fraser, whose late husband was a British subject, hung the Union Jack from a second-story balcony in an attempt to protect her home. According to family legend, Sherman became angry at the sight of the flag and threatened to burn the Fraser house until the family removed it. The present owner, Mrs. Fraser's great-granddaughter, has preserved the flag. (Photograph by Joe McTyre.)

32

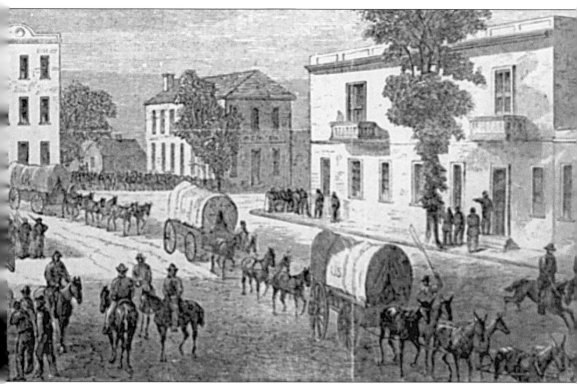

Marietta on November 13, 1864, states that the Union commander stayed at the Marietta Hotel, leaving as his troops set the fires that destroyed the town. (Drawing by Theodore R. Davis, *Harper's Weekly*.)

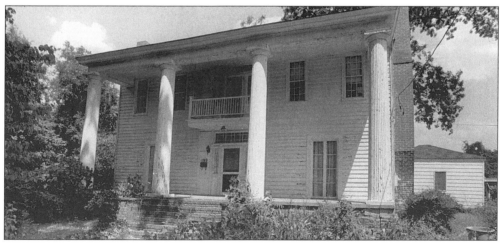

Built about 1844 by Marietta merchant Charles C. Bostwick, the classic Greek Revival Bostwick-Fraser house has a two-story portico with four Doric columns. The Atlanta Street dwelling was purchased in the early 1850s by Anne Couper Fraser of St. Simons Island. During the Civil War, Fraser's daughters Fanny, a Confederate army nurse, and Rebecca, suspected by the Federal occupation command of spying for the South, lived with their mother and sisters. The house was used as a Federal hospital in 1864 with the Fraser family confined to the upper floor. (Photo by Joe McTyre.)

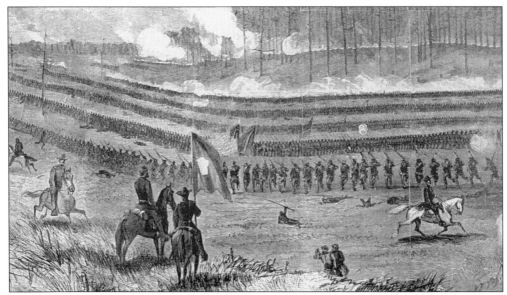

As Gen. William T. Sherman's army advanced, Gen. Joseph E. Johnston's outnumbered Confederate troops were pushed back to the Marietta vicinity where they entrenched on and around Kennesaw Mountain. By July 3, 1864, Johnston retired south to Atlanta and Federal soldiers occupied Marietta. (Drawing by Theodore R. Davis, *Harper's Weekly*.)

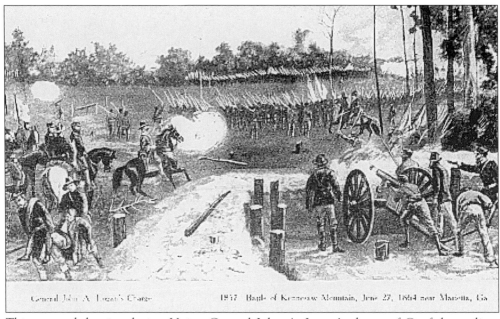

This postcard drawing depicts Union General John A. Logan's charge of Confederate lines during the Battle of Kennesaw Mountain on June 27, 1864, on Burnt Hickory Road at Pigeon Hill. The Federal assault was repulsed with heavy losses. (Carolyn Amburn collection.)

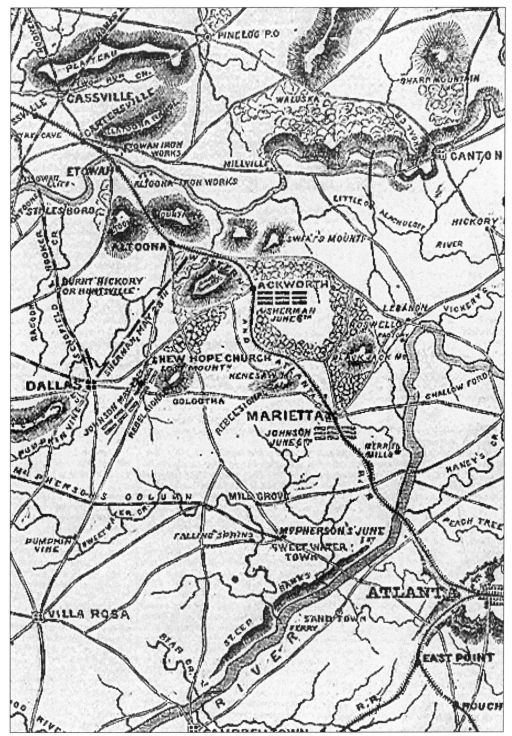

A Civil War map of Marietta and Cobb County was originally published in *Harper's Weekly* in 1864. Some place names are misspelled including Villa Rica ("Villa Rosa"), Acworth ("Ackworth"), and Allatoona ("Altoona").

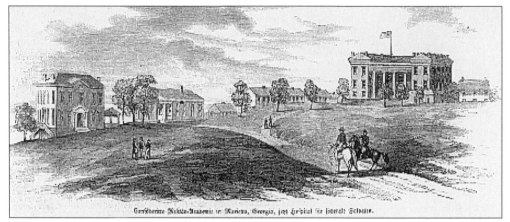

Georgia Military Institute opened in July 1851 and soon earned a reputation as an outstanding educational institution. Situated on a 110-acre site on Powder Springs Road, the campus included 18 buildings on a hill overlooking the town. Students learned the classics, took part in strict military training, and attended weekend social events for entertainment. During the Civil War, the cadets joined Confederate army units and fought in Georgia and performed provost duty. Confederate and Union troops used the school for a hospital and headquarters. On November 14, 1864, Northern troops destroyed all GMI buildings except the superintendent's house. The city built a hotel on the site in 1996. (Drawing published in a German newspaper during the Civil War.)

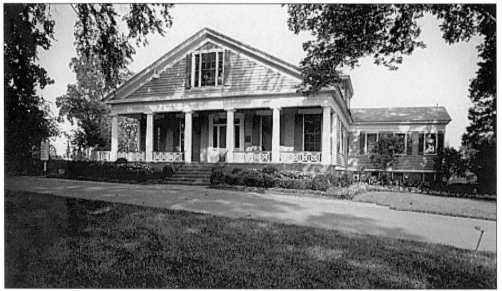

One of Marietta's significant antebellum structures is Brumby Hall on Powder Springs Road. Built in 1851, the Greek Revival raised cottage was the only building on the Georgia Military Institute campus to survive the Civil War. Col. Anoldus V. Brumby built the house for his growing family when he arrived in 1851 to serve as GMI superintendent. The Federal army used the house as a hospital in 1864. Gen. William T. Sherman may have spared the house because Colonel Brumby was a West Point classmate. Under later owners, the house was known as "The Hedges" because of the beautiful boxwoods on the grounds. The Trezevant family owned the house for about 70 years. In 1995, the city of Marietta acquired the house and gardens. (Photo by George Clark.)

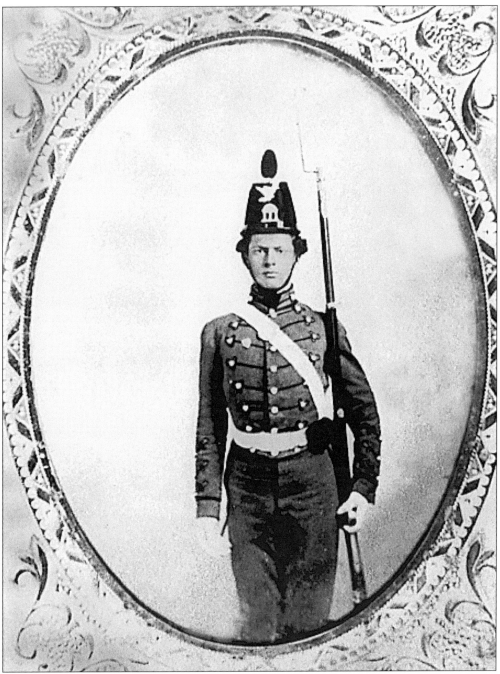

Georgia Military Institute Cadet Private James A. Blackshear is pictured in full dress uniform at the Marietta school in the late 1850s. Blackshear fought with his classmates in the Confederate army and survived the war, but died of tuberculosis in 1867. (Marietta Museum of History collection.)

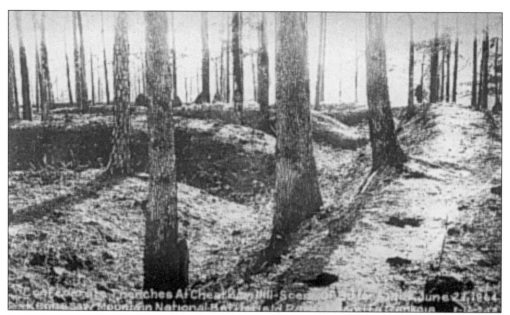

Confederate trenches at Cheatham Hill battlefield are pictured as they appeared on June 27, 1864, when some of the heaviest Civil War action in Cobb County took place. The area was defended by Gen. B. F. Cheatham's Confederate troops as Union Gen. George H. Thomas's Army of the Cumberland assaulted the Confederates near their center, incurring heavy casualties. (Carolyn Amburn collection.)

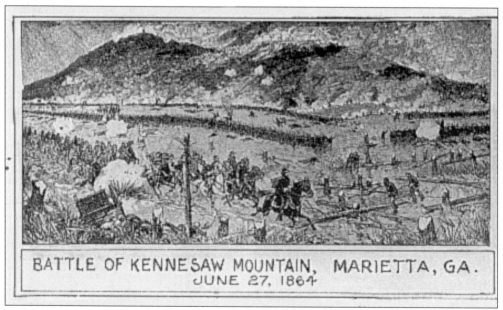

BATTLE OF KENNESAW MOUNTAIN, MARIETTA, GA.
JUNE 27, 1864

During the Battle of Kennesaw Mountain on June 27, 1864, Federal troops under Gen. William T. Sherman assaulted the Confederate center at the south end of Little Kennesaw Mountain and the Marietta-Dallas Road, but were repulsed with heavy losses. Sherman lost 2,500 men and Confederate Gen. Joseph E. Johnston lost 800. (Marietta Museum of History collection.)

38

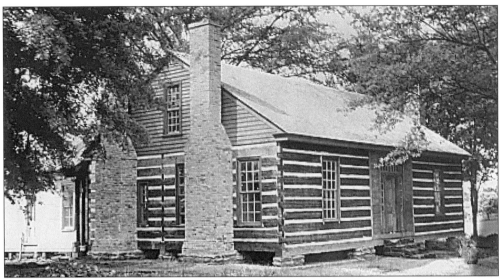

Kolb Farmhouse on Powder Springs Road is one of the last remaining log houses in the area. Pioneer settler Peter Valentine Kolb built a four-room house in the early 1850s on his farm about three miles from the town of Marietta. The original building had four chimneys, glazed windows, and an upstairs half-story. On June 22, 1864, a Confederate attack of Federal forces near Kolb's farm failed, resulting in heavy casualties. The house is owned and maintained by the National Park Service as part of the Kennesaw Mountain National Battlefield Park. (Kennesaw Mountain Battlefield Park collection.)

The Masonic Building shown was the only structure facing the square to survive the Civil War destruction of Marietta. The building was razed in 1917 for construction of the First National Bank. The original bank, on the southwest corner of the square, was a smaller version of the marble building now located on the site. (Marietta Museum of History.)

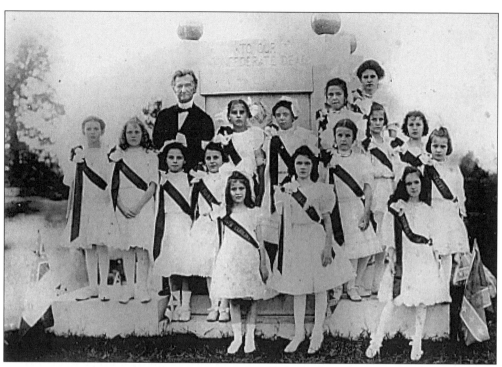

Girls in white dresses and sashes made a pretty picture in 1908 at the unveiling of a monument honoring soldiers buried in the Marietta Confederate Cemetery. Pictured from left to right are: Carrie Phillips, Sarah Patton, Page Wilder, former Confederate Gen. C. A. Evans, Julia Anderson, Ruth McCulloch, Linder Anderson, Adelaide Setze, Lois Gardner, Aimee D. Glover, Jeanette Black, Cora Brown, Emma Hedges, Pauline Manning, Sue Green, and Augusta Cohen. Marietta is one of a few cities in the nation with both Confederate and National cemeteries. (James B. Glover, V collection.)

This photograph is taken from a portrait of Jane Bolan Glover, wife of Marietta's first mayor, John Heyward Glover, Jr. It was one of four paintings stolen by Federal soldiers in 1864. The family recovered two of the portraits in New Hampshire and bought them for $50 each in the 1903, but those of Jane and John Glover have not been located. (James B. Glover V collection.)

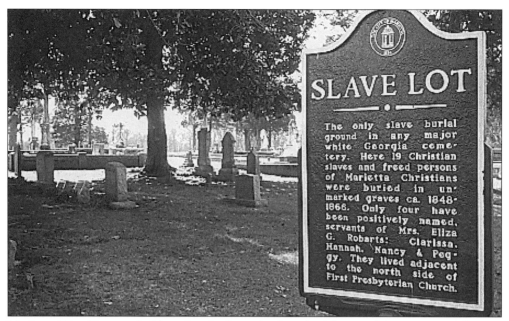

Marietta City Cemetery's Slave Lot is the only slave burial ground in any major Georgia cemetery, according to a cemetery historic marker. Between 1848 and 1866, 19 slaves and freed slaves of Marietta citizens were buried in unmarked graves. Only four of Eliza G. Robarts's servants were positively identified: Clarissa, Hannah, Nancy, and Peggy. The slaves lived with the Robarts family on Church Street. (Photograph by Joe McTyre.)

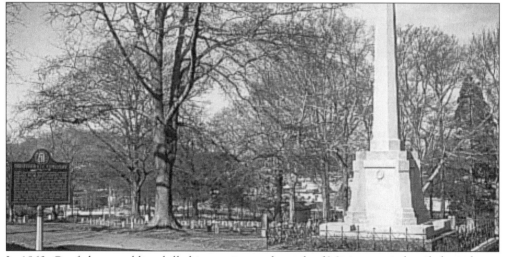

In 1863, Confederate soldiers killed in a train wreck north of Marietta were hastily buried on a lot donated by Jane Porter Glover next to the city cemetery. When Mariettans refused to rebury Southerners in the new National Cemetery after the war, five Marietta ladies initiated the Confederate Cemetery. A Baltimore woman gave two acres adjacent to the Glover tract near the railroad, and the city of Marietta donated more land for the burials. More than 3,000 soldiers from 14 states killed in nearby battles are interred there. The only private plot belongs to the family of Thomas L. Bussey, a Western & Atlantic Railroad conductor who assisted in transporting the last soldiers killed in action to the cemetery. Confederate Memorial Day services are held annually at the cemetery (Photograph by Joe McTyre.)

The Whitlock House, famous for its outstanding hospitality and good food, was owned by Milledge G. Whitlock on Whitlock Avenue. A typical menu listed four meats, six relishes, six vegetables and several other side dishes, nine desserts plus milk, coffee, and tea. The hotel's 104 guest rooms were in much demand during the summer seasons from the late 1860s, when Marietta regained its resort status, to 1889 when fire destroyed the Whitlock House. (Vanishing Georgia collection, Georgia State Archives.)

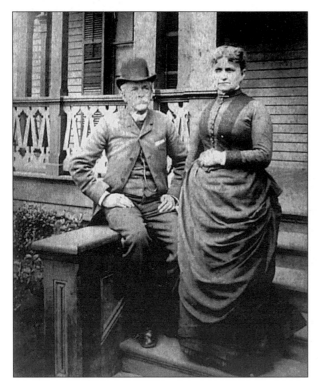

Anna and Milledge G. Whitlock are pictured in front of their hotel, the Whitlock House, in the late 1800s. The Whitlocks were known for their hospitality and operated the most popular stopping place for tourists in Marietta until fire destroyed the house. (Marietta Museum of History collection.)

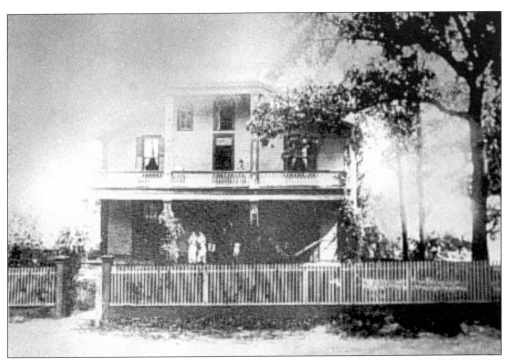

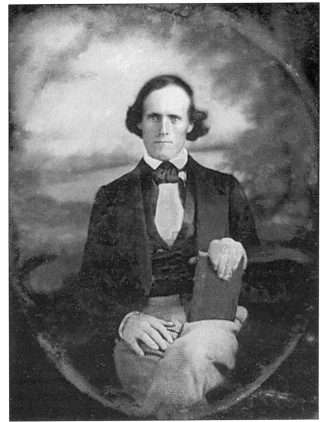

The Cole house on Washington Avenue was acquired by Henry Greene Cole a few years after it was built in the 1840s. Cole, a Union sympathizer during the Civil War, was accused of spying for the Federal army and was imprisoned late in the war by the Confederates in Charleston. His family remained in the Marietta house where Cole returned after the war's end. The 26-acre tract he donated for a National Cemetery was adjacent to the Cole house, which has been remodeled and converted into attorneys' offices. (Bayard Cole collection.)

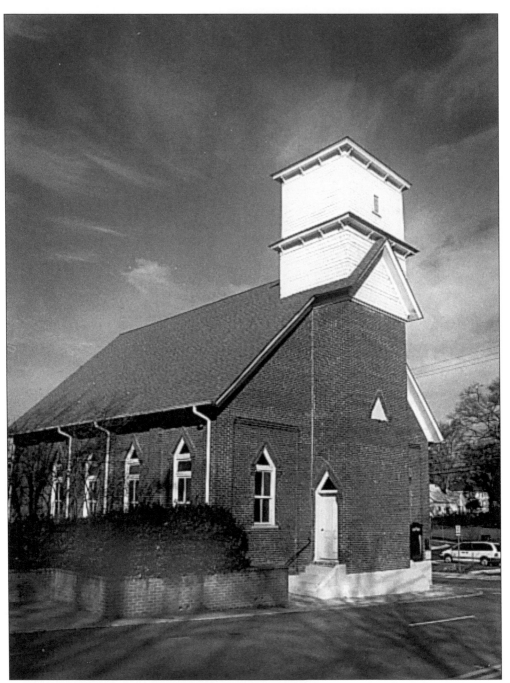

Zion Baptist Church was the first congregation in Marietta organized by former slaves who began meeting apart from the white members of First Baptist Church in 1866. The 88 charter members built a frame house of worship on land donated by First Baptist at the corner of Lemon and Haynes Streets. The congregation replaced its original building with the handmade-brick sanctuary in 1888, shown here in the same location. Today, members worship in newer facilities nearby on Lemon Street and the restored old church is used for weddings and tours. (Photo by Joe McTyre.)

Three
RECONSTRUCTION AND REBUILDING
1866–1900

Like the rest of the South, Marietta's post-war recovery was slow. Poverty and hunger were widespread; food shortages were so acute that many Cobb residents were forced to walk 20 miles to Atlanta for grain and meat distributed there[10]. Residents rebuilt homes, businesses, and industries, restored their government, and coped with the retribution of Reconstruction. City property owners saw their holdings, valued at almost $600,000 in 1860, plummet to about $375,000 by 1866. A year after the war ended, some townsmen found work helping build the Marietta National Cemetery on land donated by Henry Greene Cole, a Marietta resident and former Union spy. In July 1865, repairs to the railroad allowed trains to resume their routes through Marietta. While streets were still littered with war debris, new stores interspersed among the ruins on the town square and businesses began to revive by the late 1860s. Marietta planted new shade trees in the park and construction and repairs began. In the 1870s, the county rebuilt the courthouse and jail, more new stores appeared, and reconstruction of the mills became a priority. A private girls school opened in 1865, soon to be followed by a school for boys and several other private schools from 1870 to 1890. Again, the town drew summer visitors and attracted northerners in winter months[11]. By the turn of the century, Marietta experienced a modest revival. New buildings had been constructed all around the city square[12] by 1888, and a marble factory, the Brumby Chair Company, and the Glover Machine Works led the economic comeback[13]. Residents celebrated the installation of electricity in 1889, and water and telephone systems made life more comfortable. The first library was established and a public school opened in the late 1890s.

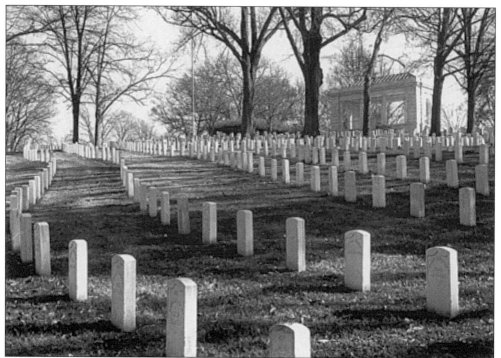

In an effort to heal rifts caused by the Civil War, a Marietta resident convicted by the Confederates of spying for the Union donated land adjacent to his house for burial of soldiers on both sides. But local residents refused Henry Greene Cole's offer to allow southern soldiers to be buried in the same ground with northerners. Today, about 10,000 Union soldiers' graves (3,000 are unknown) and military personnel from every subsequent war fought by the United States rest in the 26-acre cemetery on Roswell Street. (Photo by Joe McTyre.)

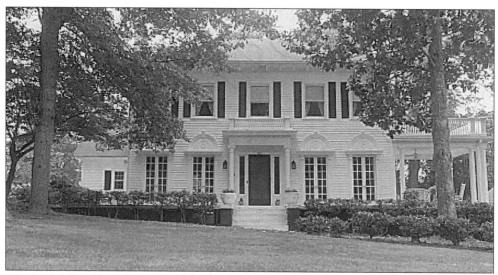

Confederate veteran William R. Montgomery built a small house in 1870 on Cherokee Street. After the area recovered from the Civil War, the family enlarged the house in the two-story traditional style. (Photo by Joe McTyre.)

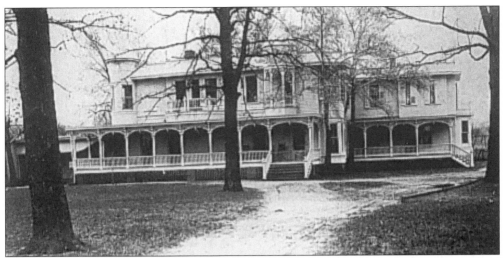

Oakmont, a stately Victorian house, was built in 1873 by William Audley Couper, formerly of St. Simons Island. Originally facing Whitlock Avenue, the dwelling shown in 1890, stands on the site of Kennesaw Hall, burned in 1864. Joseph Mackey Brown bought Oakmont in 1888, enlarging and extensively altering it. During the Depression years, the family lost the house to foreclosure and its next owner, a contractor, restored it. In 1938, Brown's son, Charles McDonald Brown, reacquired the house when he was hired as a government attorney responsible for condemnation of land for Kennesaw Mountain National Battlefield Park construction. The governor's grandson, Charles McDonald Brown Jr., is the current owner. (Charles M. Brown collection.)

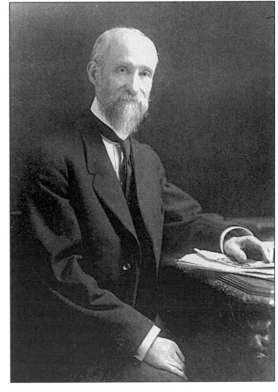

Joseph Mackey Brown (1851-1932), son of Georgia Governor Joseph Emerson Brown, was born in Canton. After graduation from Oglethorpe College, Joseph M. Brown worked as a general agent for the Western and Atlantic Railroad and was associated with the First National Bank of Marietta. When he was elected governor of Georgia in 1908, a large crowd led by a local band walked to the Brown house on Whitlock Avenue where they celebrated with fireworks, music, and cheers. Brown lost a reelection bid but won the governor's office again in 1912 when Governor Hoke Smith resigned. He came back to Marietta after his term ended in 1913. (Charles M. Brown collection.)

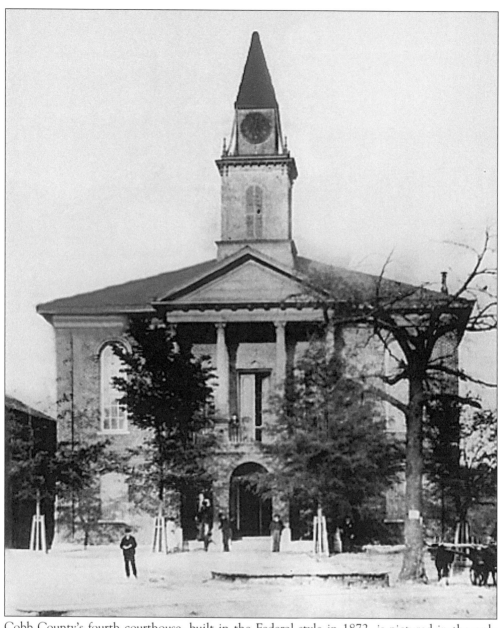

Cobb County's fourth courthouse, built in the Federal style in 1872, is pictured in the only known photograph of the building before its remodeling in 1899. (Photo restoration by Joe McTyre.)

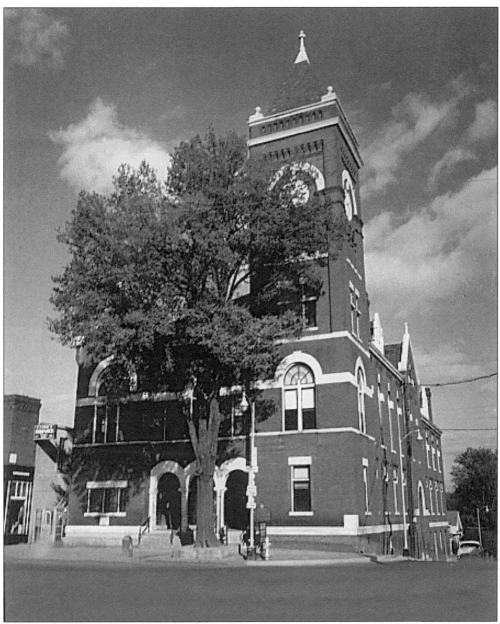

The northeast corner of the Marietta town square was the site of the Cobb County Courthouse burned by Federal soldiers in 1864 and rebuilt in 1873. A century after it was built, the county razed the court building and adjacent businesses, shown here in 1954, to build an office building and parking lot, and it is now the site of the state court building. (Photo by Joe McTyre.)

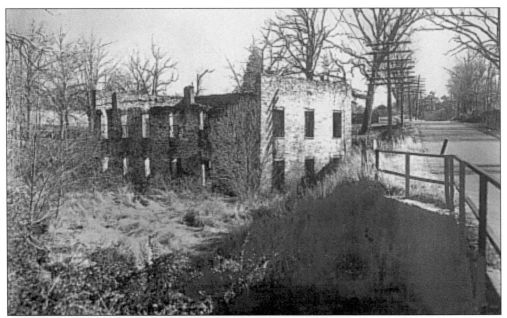

John Heyward Glover Jr. and John Wilder built a tannery on Cassville Road (now Kennesaw Avenue) in 1870. Only ruins of the two-story building remain on the busy street. (James B. Glover V collection.)

William Pinckney Stephens served throughout the Civil War in the Army of Northern Virginia and returned home and became a five-term sheriff of Cobb County. His son, William P. Stephens, was the founder of Stephens Lumber Company, a longtime family business in downtown Marietta.

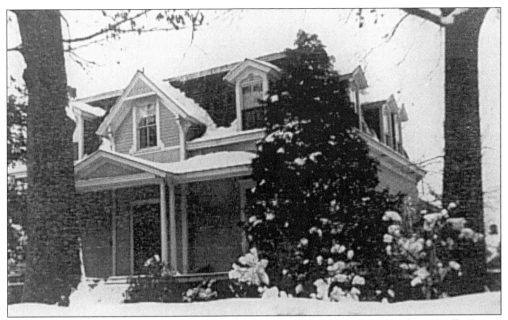

The Edmunston-Law House was built about 1872 by the Edmunston family on Polk Street. The two-story frame dwelling with French Regency features was purchased by the Laws in 1890. A century later, a new owner opened a bed and breakfast inn which draws guests from all over the United States. (Mary Ladd collection.)

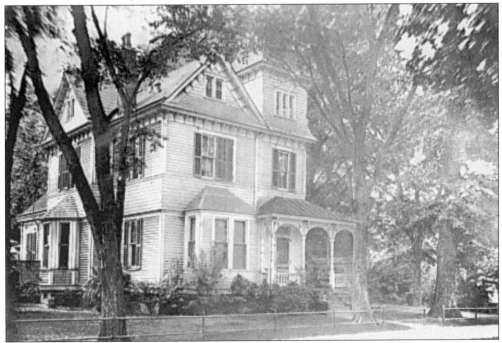

Frederick E. A. Schilling built an ornate Victorian-style house on Washington Avenue in 1887. Schilling (1849–1930) owned a thriving hardware business on the square after the Civil War. This view shows the Schilling house in the 1920s. (Vanishing Georgia collection, Ga. Dept. of Archives and History.)

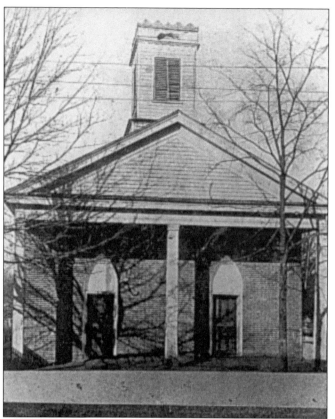

The first Baptist congregation in Marietta was organized in 1835 with 17 members who built the town's first church building, a small frame structure on the present site of the City Cemetery on Powder Springs Street. In 1843, the church donated its original lot to the city for the burial ground. From the start, the church received slaves as members, according to church records. The church's third building, shown on this page, was erected in 1848 on the north side of Kennesaw Avenue on a lot given by Judge David Irwin. The interior photograph view, taken in 1888, shows pot-bellied stoves and a long-handled offering basket. (Daniel M. Worley collection.)

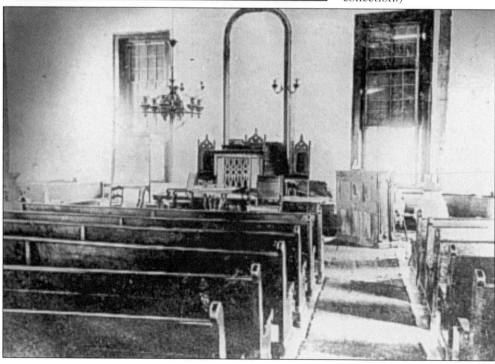

In 1897, the First Baptist Church completed a new sanctuary on Church Street, pictured above with the original steeple, and its modern look is seen below. Property for the building was donated to the church in 1890 by former Governor Joseph M. Brown. The building's unusual blend of Gothic and Roman styles incorporates Georgia marble, slate, and Stone Mountain granite. The building is now used as a chapel. (Above photograph courtesy of Ruth Anderson Northcutt collection; below by Joe McTyre.)

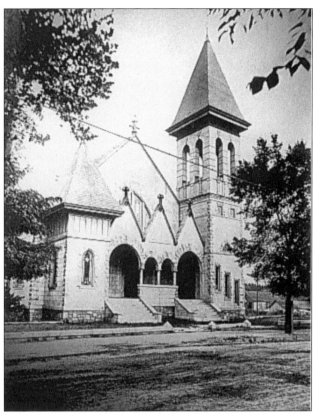

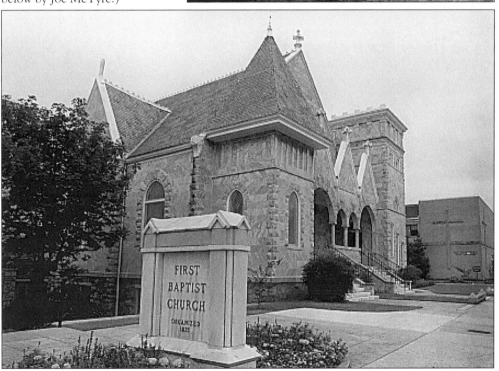

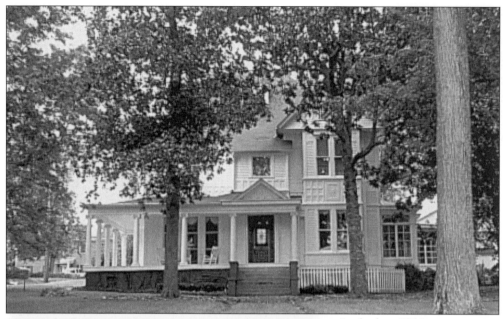

In the late 1880s, prominent public figure Alexander Stephens Clay built the two-story Queen Anne-style house with steep hipped roof, cross gables, and a wrap-around front porch on Atlanta Street. The site was the original location of the Slaughter cottage. Clay family members and business office employees report that the house has a resident "ghost." (Photograph by Joe McTyre.)

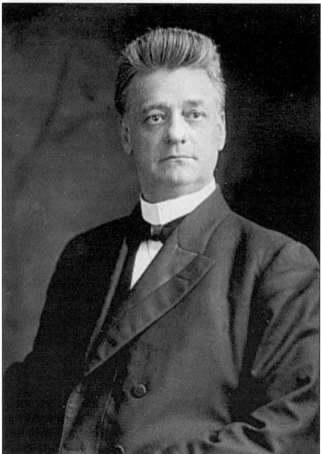

Alexander Stephens Clay (1853–1910), a Cobb County native, served as a Marietta city councilman, state representative, and state senator. He was elected to the U.S. Senate in 1896 and served three terms. The monument in Glover Park describes Clay as "an exemplary citizen, faithful friend and trusted and honored public servant." (Charles C. Clay collection.)

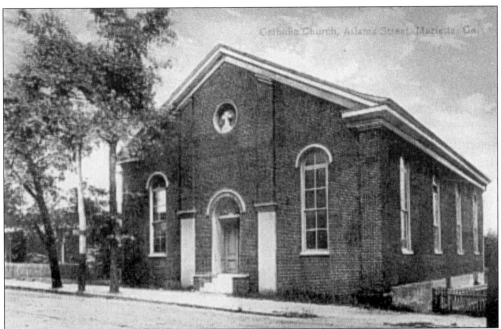

St. Joseph Catholic Church
acquired the former Methodist
church as its first sanctuary,
shown above and below.
In 1929, the parish built a new
church on Church Street.

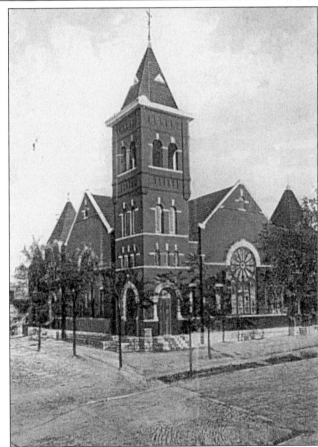

The Methodists were the first
to organize a church in Marietta
in 1833. Their first house of
worship was a log building on
Powder Springs Street. In 1848,
the congregation built a brick
sanctuary on Atlanta Street
which was used until 1900
when a new structure was
dedicated at Atlanta and
Anderson Streets. For a short
time, the older building was an
opera house and it was later
purchased by St. Joseph
Catholic parish in the early
1900s. (First Methodist Church
collection.)

Robert Hull Northcutt and John R. Winters, from two of Marietta's pioneer families, drew lots in the 1832 lottery and built houses side by side. The Victorian dwellings were located on Waverly Way where Winters Street intersects, now the site of a parking lot. Shown are the houses which burned in 1912. (Ruth Anderson Northcutt collection.)

The Sessions family built the Queen Anne-style house pictured here next to the Sessions-Blair house on Cherokee Street in 1875. Posing in the front yard were the Sessions' granddaughters, Ruth and Jeannette Anderson, with the family cook, Addie McAfee. The house was razed in the 1920s. (Ruth Anderson Northcutt collection.)

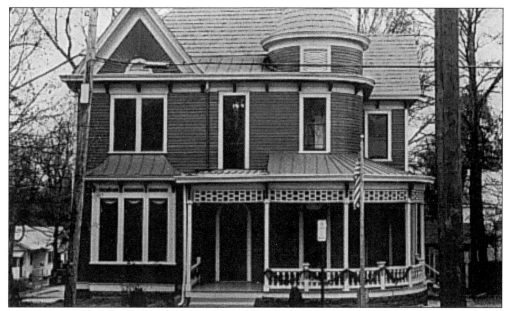

The Stanley House was built in 1898 on Church Street by W.P. Stephens for Mrs. Felie Woodrow, President Woodrow Wilson's aunt. Originally a summer cottage, the Queen Anne-style house has been restored and is now a bed and breakfast inn. (Philip Secrist collection.)

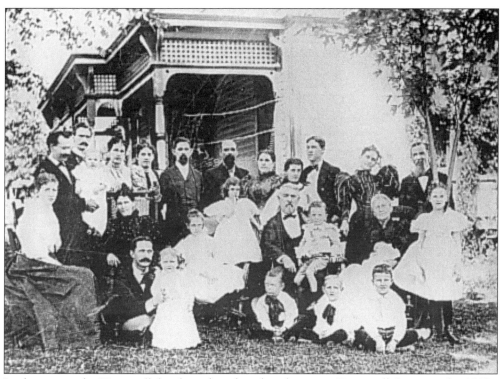

In this scene, the Trammell family gathered at their home on Trammell Street in the 1880s. The house was built about the same time by L.N. Trammell, a director of one of Marietta's earliest banks. (Marietta Museum of History collection.)

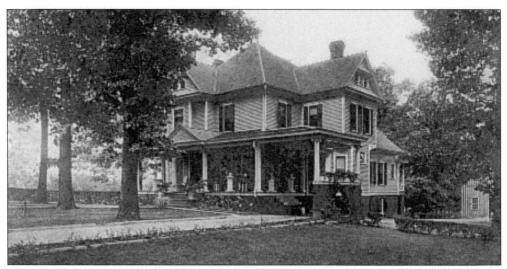

Judge William M. Sessions built the two-story frame Victorian-style house on Cherokee Street for his son, Moultrie, in 1895. Judge Daniel W. Blair bought the house and grounds in 1902 and his son, L.M. "Rip" Blair, and family remodeled it and created a nine-acre park-like setting. The Blair family lived there until 1992. The house is now used by for special events by an exclusive residential development, Blair Valley Estates.

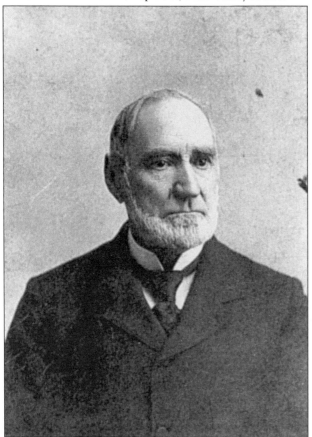

Judge William Moultrie Sessions served one term as Marietta mayor, from 1885 to 1886. Born in Spalding County in 1827, he read law with P.B. Cox, was admitted to the bar in 1849, and taught school two years before beginning a law practice.
In 1860, Sessions was elected a superior court judge in the Brunswick circuit, serving there for 14 years. After retiring as a judge, he moved to Marietta in 1875 and practiced law. He died in 1903. (Sessions-Edwards collection.)

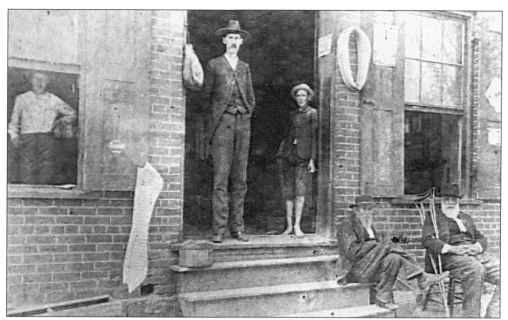

Parks Groover owned and operated Groover General Store on the corner of Atlanta Street and Washington Avenue, where Tommy's is located. In this scene in 1885, Groover and his son, Joe, stand in the store's doorway. In 1932, Joe, Paul, and Jake Groover opened Groover Hardware on Washington Avenue. The Groovers sold their business in 1972. The store is located on Roswell Street. (Vanishing Georgia collection, Ga. Dept. of Archives and History.)

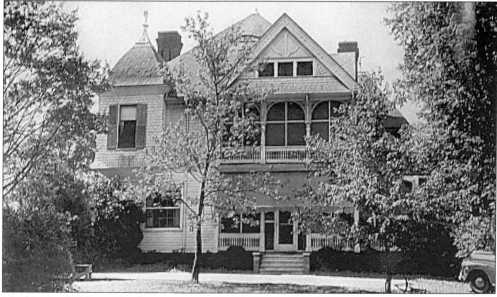

Mockingbird Hill was built as a summer residence in 1888 by Ervin Maxwell of the Maxwell House Coffee Company. Later owners were Samuel D. Rambo and Dr. Ralph Fowler. The Queen Anne-style house facing McDonald Street is on the site of an antebellum structure used as a hospital and burned during the Civil War. The original kitchen outbuilding is all that remains of the older house. Among its interior features are a variety of woods including English walnut, Indiana butternut, pine, oak, and Honduras mahogany. (Bill Kinney collection.)

Oakhurst was built in 1880 as a summer home by Abraham F. Clarke and his family. During the Clarkes' residence, Clarke's daughter, Sarah Freeman Clarke, started a lending library at the house. Other longtime owners were the Little, Hodges, and Knox families. (Photograph by Joe McTyre.)

In 1893 the city of Marietta dedicated its first library building, the Clarke Library, in honor of Sarah Freeman Clarke (1808–1896) who founded a lending library at her home on Whitlock Avenue in 1882. Miss Clarke donated 2,000 volumes to the library. The unusual octagonal building has a skylight with galvanized iron frame and side ventilators. Since 1963, it has been used as business offices. (Photograph by Joe McTyre.)

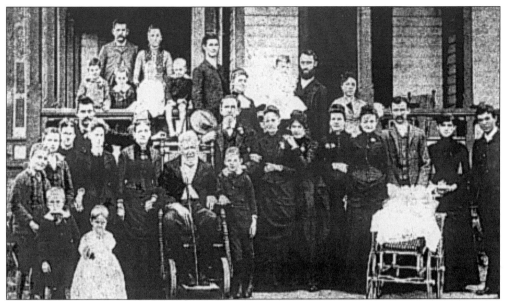

Thomas M. Brumby and his family gathered on the porch of Tower Oaks, an outstanding two-story Victorian house on Kennesaw Avenue. Identified seated, not in order, are: Thomas and Lula Brumby, T.M. Brumby Jr., Mariah, J.R. and Robert Brumby; standing are: James, Laura, Robert M., Bolan, James R., Jr., and Isabel Brumby. Also shown: Virginia Wellons, Mr. and Mrs. Frank Wellons, Ben and Jenny Wellons, Mr. and Mrs. John G. Brumby, Clarence Brumby, James and Ellis Talley, Nellie Talley, Dr. Samuel Brumby, Sue and Carrie Brumby, and Emma Speight. Leaning against the post are Richard B. Simpson and Catherine Simpson. (Otis A. Brumby collection.)

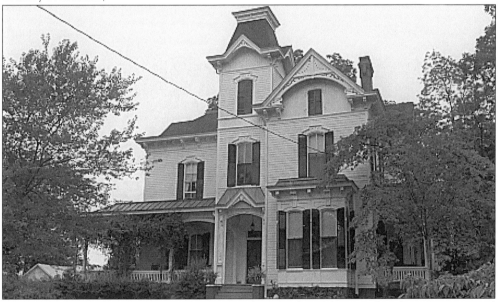

Tower Oaks was built in 1882 by James R. Brumby, founder of the Brumby Chair Company and manufacturer of the famous Brumby rocker. A Queen Anne tower tops the two-story Victorian dwelling. The Brumbys lived in the house until 1922 when Judge Samuel Sibley acquired the property. His descendants still live there. (Photograph by Joe McTyre.)

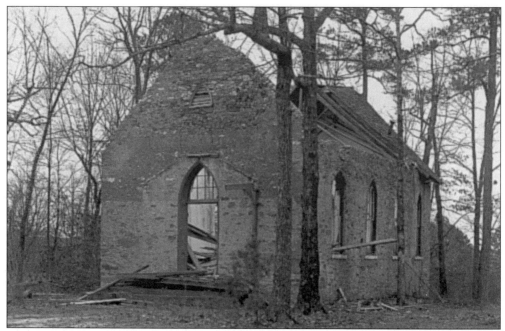

Nesbitt Chapel was built in 1886 by Col. Robert T. Nesbitt on his Farm Forest Plantation on Powder Springs Road. Nesbitt's deed for the building, also called Union Chapel, specified that it be used for multi-denominational worship or for educational purposes. Several denominations and a school held services and classes there. By the 1940s, the chapel's deterioration made it unsafe. Only two walls, the gothic front doorway, and the chancel remain. (Photograph by Joe McTyre.)

Built around 1900 by Warren Crockett, the house on Cherokee Street at Forest Avenue was known to many Marietta residents as Grey Gables. Crockett inherited the lot from his grandmother, Ella Crockett, who purchased the tract in the 1880s. Crockett's daughters, Louise and Allie, both school teachers, ran a boarding house there. The Benson family acquired the house as a residence in 1924, and sold it in 1941 to Dr. Martin Teem who had a medical clinic and residence there. His son, Dr. Martin Teem Jr., practiced medicine there until he sold it to a bank in 1997. During remodeling for the bank's offices, several antique items, including a croquet set, were found in the wall of a sleeping porch. (Photograph by Joe McTyre.)

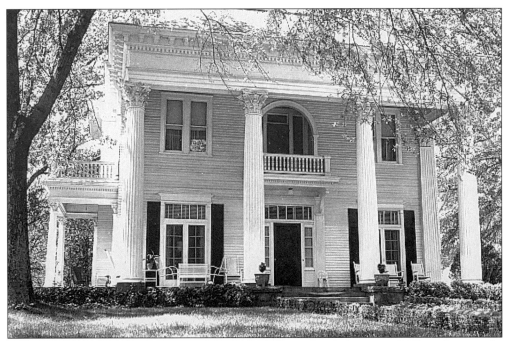

Mills McNeel built a large two-story classic Greek Revival style house in 1895 on the site of a former tanyard on Church Street. State Supreme Court justice J. Harold Hawkins acquired the dwelling in the 1930s. Present owners named the house Hamrick Hall. (Photograph by Joe McTyre.)

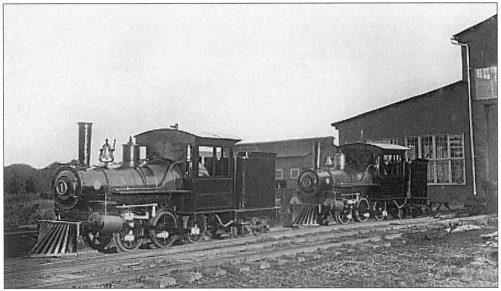

Marietta's first industry, Glover Machine Works, was incorporated in 1892 by James Bolan Glover, Jr. Originally located beside the railroad on the south side of Whitlock Avenue, Glover relocated his business to Butler Street in 1903 and produced more than 200 steam locomotives until 1926, when the owners changed production to pipe fittings and nuclear castings. The building was demolished in 1995 when the Glovers moved the company to Cordele. (James B. Glover V collection.)

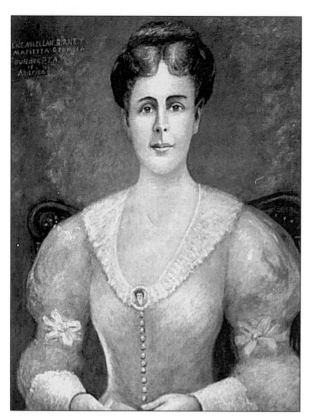

Alice McClellan Birney, co-founder of the National Parent Teacher Association, was born in Marietta in 1858 and attended the Marietta Female Academy before completing high school in Atlanta. After a year of college, Miss McClellan taught at the Haynes Street school and lived in the house originally on Church Street. After her marriage she moved to South Carolina, but returned to Marietta when her husband died. In 1892, she married Theodore Birney. During the Birneys' residence in Washington, D.C., she spearheaded the organization of the first Parent Teacher Association (originally the National Congress of Mothers) in 1897, was received at the White House, and served as the organization's president until 1902. (Photograph by Joe McTyre—Marietta Museum of History portrait.)

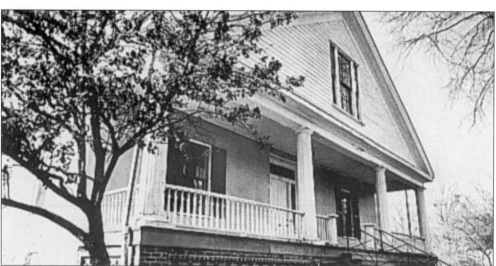

The McClellan-Birney house built in the early 1850s was originally located in a shady block on Church Street, north of the Presbyterian church. Mary Ann Nesbitt owned the two-story Greek Revival house in 1865 where the McClellan family later resided for several years. From 1887 until the 1960s, when the First Presbyterian Church acquired the property, the house was the St. James Episcopal Church rectory. In the 1980s, the house's current owner moved it to Kennesaw Avenue to preserve it after the Presbyterian church planned to build a parking lot on the site. (Photograph by Joe McTyre.)

Edward Ralph Hunt, born in Marietta in 1876, served as a quartermaster sergeant in the Marietta Rifles during the Spanish American War. After his discharge in 1898, he practiced law in Marietta and was elected mayor of Marietta in January 1926, but resigned in October because his duties as a circuit judge required frequent absences. Hunt was vice president of a Marietta bank and a vestryman at St. James Church. He died in 1939. (Floy Hunt Hodges collection.)

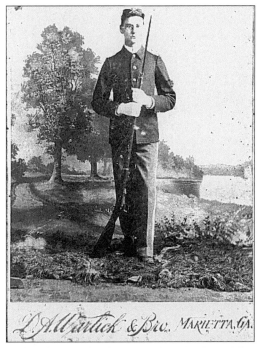

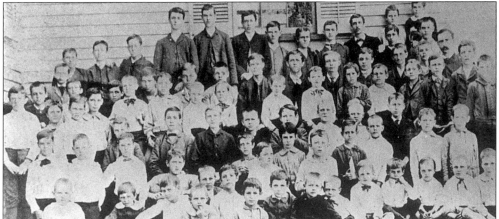

Marietta Male Academy students in 1886, pictured from left to right, are: (front row) Hugh Montgomery, Homer McClatchey, Paul Witt, unidentified, Ben Underwood, Jack Kiser, Dan Manget, D. F. McClatchey, George Turner, Lewis Turner, Clarence Brumby, F. Johnson, Ralph Murray, Jim Garrison, unidentified, and Milo Witt; (second row) Will Matthews, Will Neal, Jack Massey, Ben Brumby, Harry Leake, A. V. Cortelyou, Harry Humphries, Gus York, Ed Murray, unidentified, and unidentified; (third row) Dees Murray, Will King, Will Redding, Earnest Faw, Bolan Brumby, unidentified, Morris Hirsch, Chipley Steze, Glen Marchman, Frank Sanges, Jim McCutcheon, Carol Chamberlain, George F. Montgomery, Coy Chamberlain, Clyde Matthews, Jim Hammett, Tom Brumby, Emmett Hamby, Frank Freyer, John Boston, Charlie Barker, unidentified, Pat Mell, Tiny Dunwody, unidentified, Jaught Kiser, Frank Mullins, Tom Setze, Bob Nesbit, Fred Barnes, and Professor J. C. Harris; (fourth row) Will Gramling, Jim Redding, D. C. Cole, Jim Groves, Charlie Rogers, Jerome Johnson, Harry Cole, Frank Boston, George D. Anderson, Mongin Brumby, and unidentified. (Ruth A. Northcutt collection.)

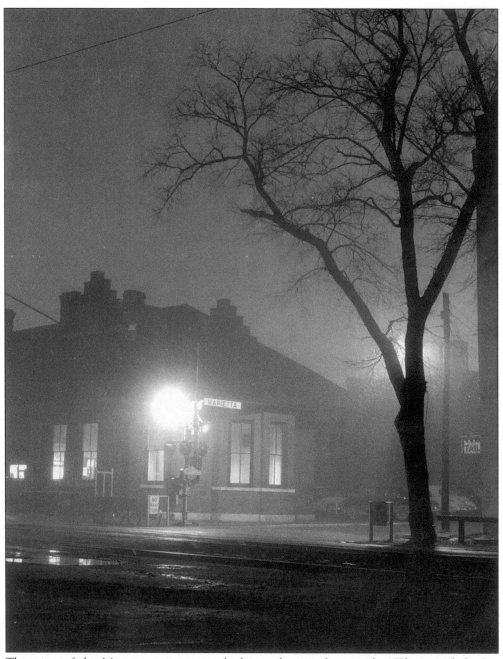

This view of the Marietta train station looks north on a foggy night. (Photograph by Joe McTyre.)

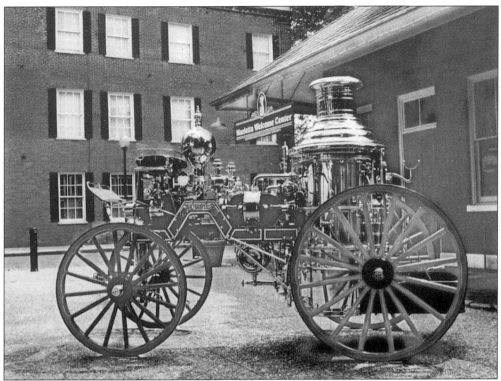

The Marietta Fire Department's steam fire pumper, the "Aurora," serviced the city of Marietta from its arrival in 1879 until 1921, and is one of only a few of its kind remaining. The Aurora has been fully restored and is on exhibit in the Marietta Fire Department Museum on Haynes Street. (Marietta Fire Department collection.)

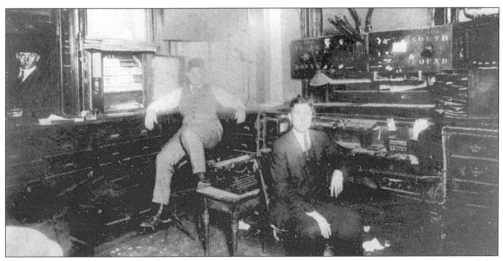

The Western & Atlantic Railroad built a passenger depot in Marietta in 1898, on the site of the original 1840s depot destroyed by General William T. Sherman's Federal troops who occupied the town in 1864. Today it houses the Marietta Welcome Center and Visitors Bureau. Its interior appearance is similar to the way it looked 100 years ago. (Marietta Welcome Center.)

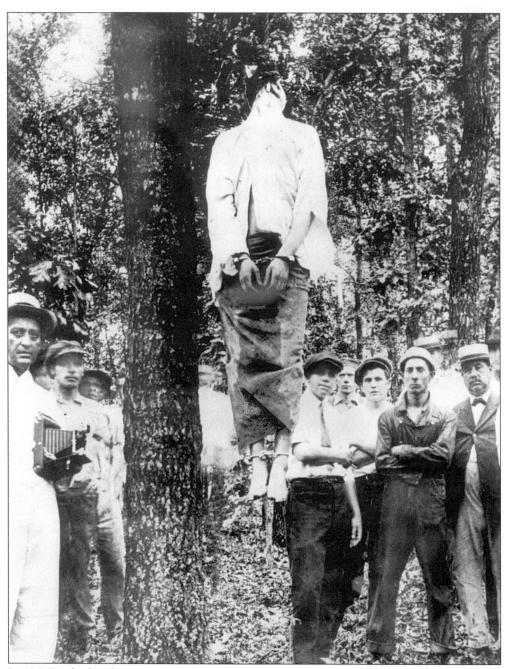

Leo M. Frank, the plant superintendent convicted of Mary Phagan's murder, was taken by force from a Milledgeville prison in 1915. The angry mob, presumably from Marietta, hung Frank after Georgia Gov. John M. Slaton commuted his death sentence. Almost 70 years later, one of Frank's co-workers gave an eyewitness account to exonerate him. Frank received a posthumous pardon in 1986. (Joe McTyre collection.)

Four

GROWTH AND DEPRESSION
1900–1940

While Marietta enjoyed a measure of recovery, Cobb County farmers experienced hardships because of low market prices [14]. The local population grew slowly—Marietta had about 4,500 residents in 1900. The first street to be paved with bricks was Atlanta Street in 1917 [15]. In 1905, the Atlanta Interurban Railway began a regular Marietta-Atlanta run, transporting passengers and freight several times a day. The rail line helped spur residential development and Mariettans commuted to jobs in Atlanta. The railway was disbanded in 1947 when improved roads and increasing automobile ownership cut into the volume of public transportation. The first subdivision construction began in the early 1900s including the extension of Church Street through the Freyer/Denmead property in 1905. African-American neighborhoods were located in the northwest part of the city and many were destroyed during redevelopment as public housing projects [16]. When the United States entered World War I in 1917, Marietta men again went off to fight while those too old for the draft organized a home guard unit [17]. Women volunteered at Red Cross workrooms and those who had made clothing for men in the Confederate army taught younger women to sew for another generation of soldiers [18]. During the war, an army training site built near the city brought contact between townspeople and soldiers. Mariettans welcomed the soldiers into their homes, churches, and social life as they had embraced the GMI cadets 50 years earlier. Marietta and Cobb County residents celebrated their centennial in 1933 in the midst of the Great Depression which enveloped the entire nation. Construction declined, cotton prices dropped drastically, and incomes were curtailed as never before [19]. About 7,600 people lived in the city in 1930.

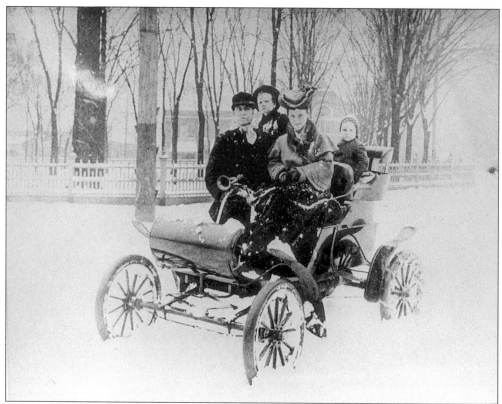

Marietta's first automobile was the object of much attention in 1902. Shown are Bolan and Ida Brumby with their children, Lawrence and Bolan Jr., in their new Oldsmobile. (Otis A. Brumby collection.)

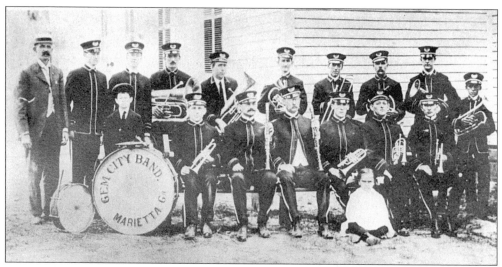

Marietta became known as the "Gem City" in the late 1800s when a prominent resident, Gov. Joseph M. Brown, referred to his hometown as "a gem of a city." About 1900, several Marietta men formed a band which played on holidays and special occasions. Members are shown here with their instruments, accompanied by a child. (Marietta Museum of History collection.)

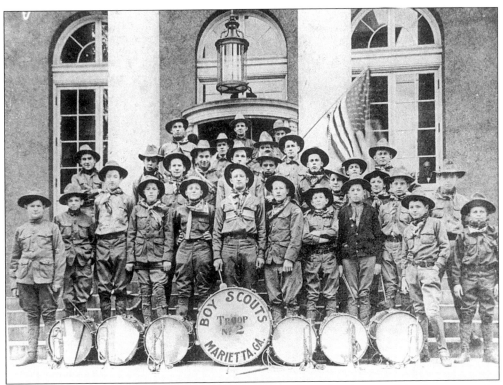

Boy Scout Troop 2 was organized in 1910 and soon formed a drum and bugle corps and a football team. Pictured in front of the Marietta Post Office on Atlanta Street in 1912 are: Earl Byerle, Fred Morris Jr., James Coryell, Claud Gatlin, Lewis Hoppe, Malcolm Whitlock, Richard Marchman, Harrison Smith, Hugh Blair, Frank Casper, Jarrell Black, Ernest Gifford, Eugene McNeel, Tom Read, Morgan McNeel Jr., Frank Ferris, Wiley Blair, Bolan Brumby Jr., Edward Groves, Mills McNeel, Sam Rambo, Scoutmaster Fred Morris, Lucius Clay, Charlie Phillips, and John Heck. (Worley collection.)

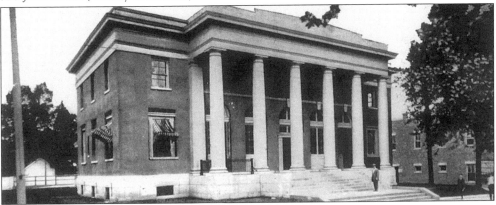

Mariettans took pride in their new post office, built on Atlanta Street in 1909. The two-story Greek Revival building's front portico was the background for many early photographs. When a new post office opened on Lawrence Street in 1963, the structure housed the Cobb County Library's central office. After the library moved into its new quarters in 1989, the building became the home of the Marietta-Cobb Museum of Art. (Marietta Museum of History Collection.)

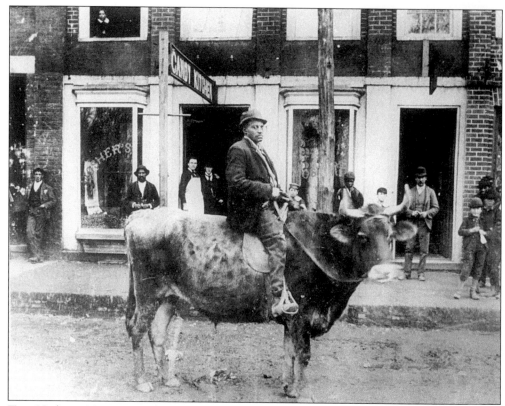

Tom Hodge, a Marietta resident, made a living hauling and selling stove wood using his sturdy bull. In this early 1900s view of Hodge on the south side of the park square, Mosher's Candy Kitchen is the background with store owner Mosher in an apron standing in a doorway. The store, which also sold ice cream, was a regular hangout for young people in the late 1800s and early 1900s. (Marietta Museum of History Collection.)

A Marietta woman braves the cold in the early 1900s in this view of Glover Park. (James B. Glover V collection.)

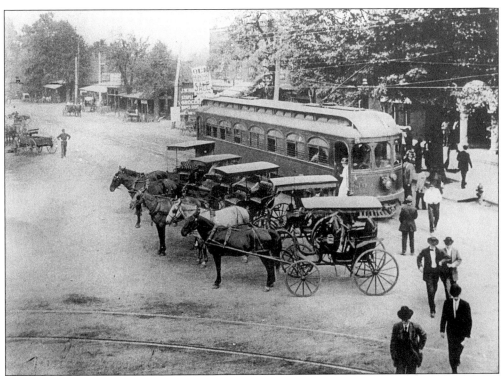

In this early 1900s scene, horse-drawn buggies and wagons lined up on the East Marietta square to meet passengers disembarking from the electric streetcars in front of the courthouse. The Atlanta Interurban Railway line operated between Marietta and Atlanta from 1905 to 1947. (Bill Kinney collection.)

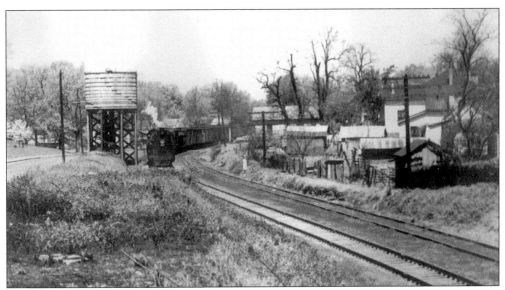

A steam locomotive headed south past the Marietta water tower near the Goss Street crossing in the 1920s. (James B. Glover V collection.)

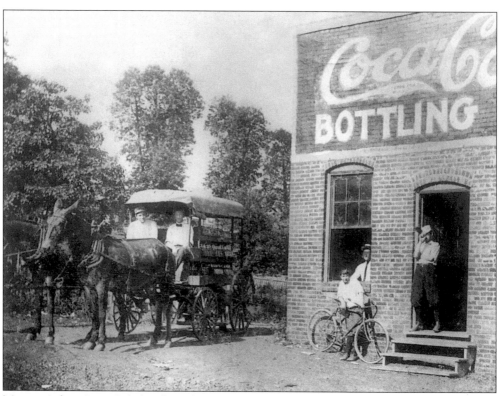

Marietta's first Coca-Cola bottling plant was built on Husk Street in 1910. This scene includes employees driving a delivery wagon. (James B. Glover V collection.)

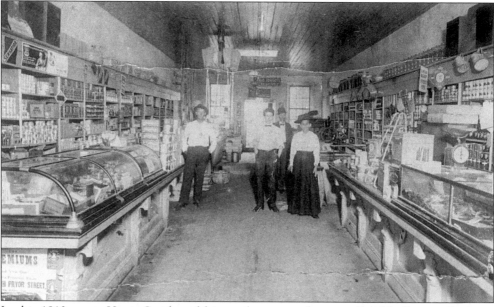

In this 1910 scene, Henry Smith and his employees are shown at Smith's Grocery Store on Church Street. (Mary Frances Smith Anderson collection.)

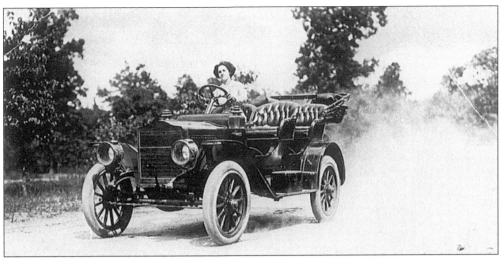

In 1910, few women drove cars, especially not their own. One Marietta woman ahead of her time was Regina Rambo, who drove throughout the state, winning the title of the first woman to drive a car 1,000 miles in Georgia. She drove her $2,750 Columbia as she participated in a "good roads tour" sponsored by *The Atlanta Constitution*. Miss Rambo's trip took her over rough roads, in some places only paths. Her driving costume was a tan auto cloak, a brown bonnet with rosettes and long streamers of veiling on each side, and brown gauntlets. She later married Dr. Warren Benson of Marietta. (Regina Goldsworthy Stott collection.)

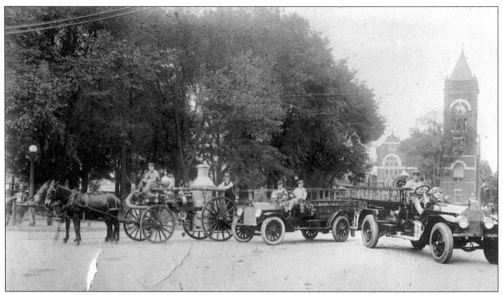

The Marietta Fire Department is pictured with the steam fire pumper, the "Aurora," in 1915. The engine serviced the city of Marietta from 1879 until 1921. The Aurora, one of only a few of its kind remaining, has been restored and is an exhibit at the Marietta Fire Department Museum on Haynes Street. (Vanishing Georgia collection, Ga. Dept. of Archives and History.)

Samuel Grady Barfield (1896–1962) is shown in his World War I U.S. Navy uniform. A lifelong Marietta resident, Barfield operated Sherry's Candy Kitchen on Cherokee Street for several years. (Yvonne Brand Heaton collection.)

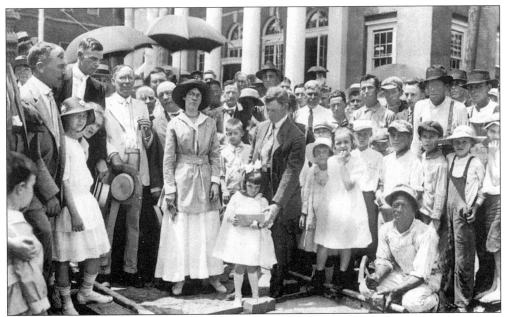

Citizens turned out in 1917 to watch the first paving of the square, which was laid by a single brick mason at a rate of about 1,700 bricks a day. "Little Jim" Lucas, an employee of Pittman Construction Company in Atlanta, worked at a rapid pace, flipping bricks into place over the entire square. Shown in the center front is Mayor James Brumby, looking down at daughter Marianne. The post office is in the background. (Amanda Canup collection.)

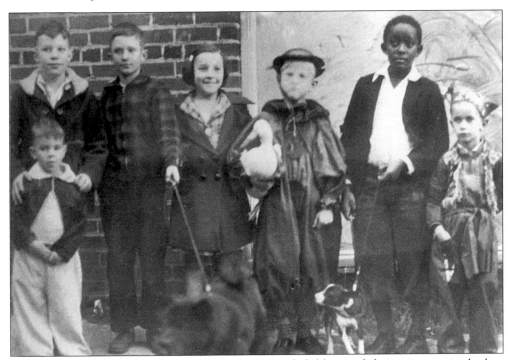

A pet show on Alexander Street in Marietta attracted children and their prize pets in the late 1930s. (Vanishing Georgia collection, Ga. Dept. of Archives and History.)

This 1920s view of the square looks west with Allen's Drug Store on the corner. (James B. Glover V collection.)

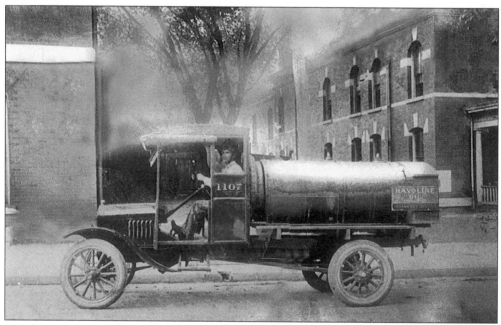

R.L. Hogg is shown driving his gasoline delivery truck on Washington Avenue in this early 1900s picture. In the background is the courthouse on the right and the jail on the left. (Amanda Canup collection.)

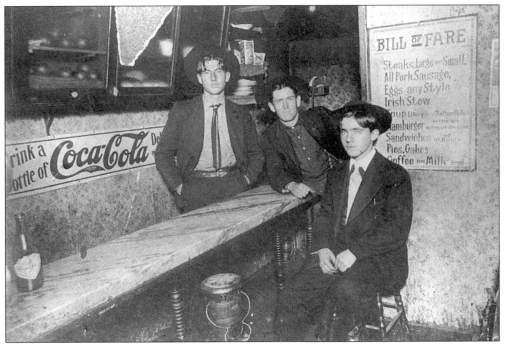

The Smith Lunch Stand, owned by William L. Smith, operated on Mill Street in the early 1900s. In this 1905 scene are from left to right Henry Smith, Charlie Smith, and ? Dobbs. (Mary Frances and Joel Anderson collection.)

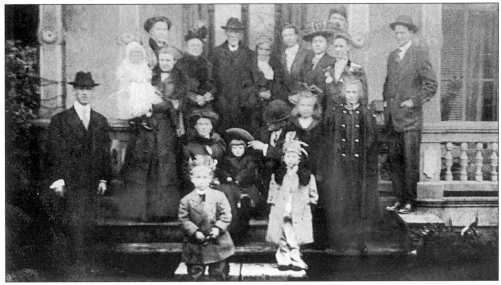

Four generations of the Glover family gathered for this photograph taken in 1909 at the Glover house on Whitlock Avenue. Pictured from left to right are: (first row) J. Bolan Glover III, and Robert Dunwody; (second row) J. Wilder Glover, Jane Glover Van Renssaelaer, Katrina Van Renssaelaer, Fleming Van Renssaelaer, Aimee D. Glover, and Fredonia Field; (third row) Frances Welsh, Earle Glover Welsh, Fannie Glover, and George V. Welsh; (fourth row) Anne Brumby Field, Anne E. Brumby Glover, James Bolan Glover, Jane Bolan Glover, Maybelle Glover, Aimee Dunwody Glover, and Marcus H. Field. (James B. Glover V collection.)

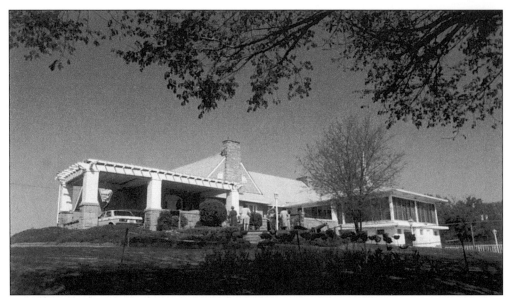

In its 84-year history, the Marietta Country Club has built two golf courses and club houses, both on Civil War sites. In 1915, a group of Marietta men formed a golf club and played on a three-hole course on the site of the Georgia Military Institute on Powder Springs Street, where cadets trained for service in the Confederate army. The group bought additional land and became incorporated as the Marietta Golf and Country Club, expanding to a nine-hole course and erecting a clubhouse in 1917. Another nine holes were added to the course in 1966. In 1990, the club relocated to a larger tract on Stilesboro Road in west Cobb County, scene of some of the bloodiest Civil War battles in the area in 1864. (Photograph by Joe McTyre.)

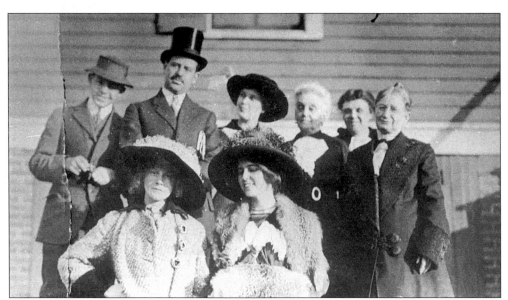

In this 1913 Christmas scene, a group of friends and relatives was dressed up for a holiday outing. Pictured from left to right are: Morgan McNeel Jr., Morgan McNeel Sr., Mary Northcutt, Ada Freyer, Ada Freyer McNeel, Elizabeth Reid McNeel, Sarah Cortelyou, and Minnie Lou McNeel. (Lila McNeel Campbell collection.)

Anne Brumby Field of Marietta is shown before her wedding to William Magruder Brumby, her third cousin, on October 12, 1915. The wedding, which helped heal a rift between the two families, took place at the Whitlock Avenue home of the bride's grandfather, James B. Glover Sr. of Marietta. (James B. Glover V collection.)

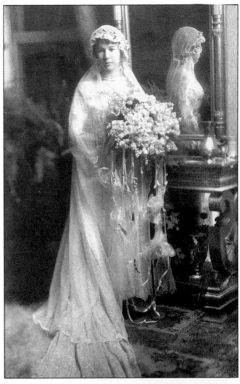

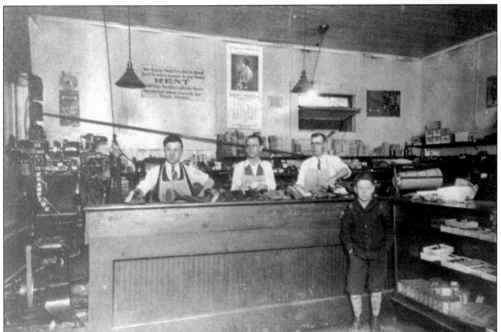

Lovvorn's Shoe Shop was opened in 1925 by E.P. Lovvorn, who operated it until 1940 when he sold the business to Emmet Connally. In 1976, Connally sold the shop to Lovvorn's family who closed it in 1981. The business, now the Marietta Shoe Shop on Church Street, is the only downtown store to continue operating in the same location. (Dave Clackum collection.)

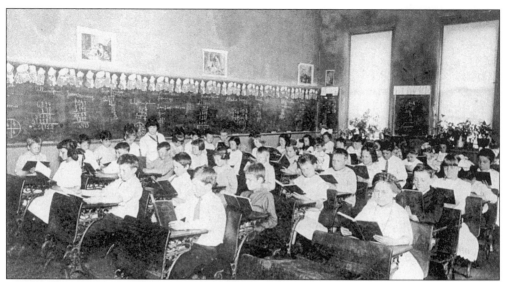

Fifth grade students at Waterman Street School are shown with their teacher in 1913. The school opened in 1894, two years after Marietta's public school system was established. The school closed in the late 1960s and, after the school property was sold in 1970 to the Salvation Army, the building was destroyed by fire. (Amanda Canup collection.)

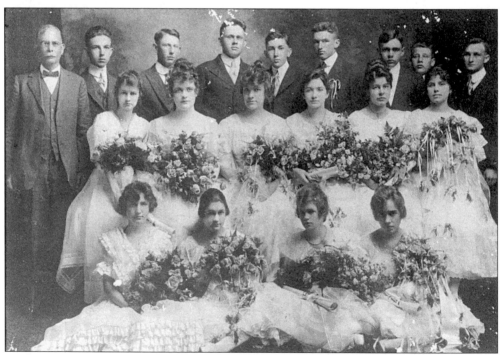

Marietta High School's Class of 1916 posed for this picture on May 19, 1916. Shown from left to right are: (front row) Mary Frances Gilbert, unidentified, Fredonia Field, and Hattie Black; (middle row) Emma Hedges, Annie Hahr, Pauline Manning, Mary Benson, unidentified, and unidentified; (back row) Professor W. T. Dumas, Principal Milton McCleskey, George Whorton, John Heck, four unidentified, and Warren Dobbs. (Ann Whorton Wyatt collection.)

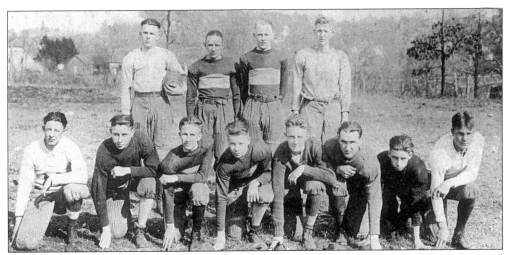

Members of the Marietta High School Blue Devils football team are shown in 1918. Pictured from left to right are: (front row) Eugene Duncan, Clarence Worley, Lewis Hibble, Eugene Lewis, Bill Shippen, Clayton Sewell, Douglas McNeel, and Mongin Brumby; (back row) Wallace Montgomery, Lee Sessions, S. A. Connor, and Candler Campbell. (Ruth Anderson Northcutt collection.)

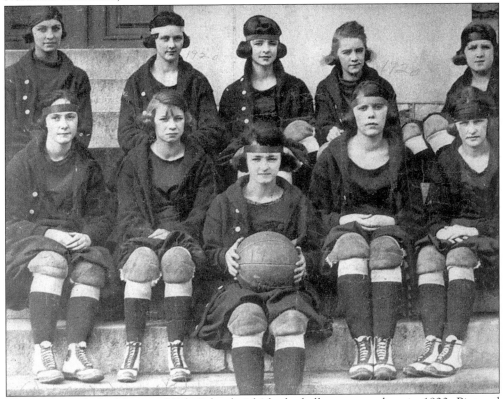

This scene includes Marietta High School girls' basketball team members in 1920. Pictured from left to right are: (front row) Harriette Leake, Margaret McNeel, Ruth Galley, Gladys Gober, and Emmie Montgomery; (back row) Gertie Morris, Ruby Mayes, Adelle Moss, Lillian Jolley, and Lucy Tate. (Gretchen Griggs Vaughan collection.)

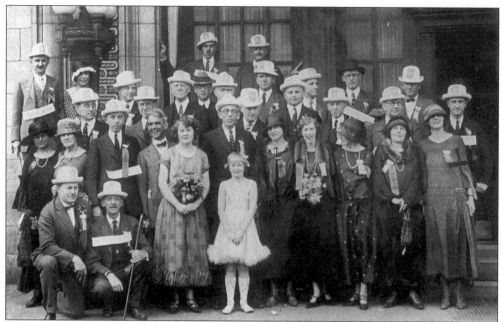

Marietta Rotary Club members traveled to the state convention in Macon in 1921. This scene includes, from left to right: (first row) Otis Brumby, Len Baldwin, Sarah Cortelyou, and Florence Hancock; (second row) Emma Irving, Sally Hancock, Guy Northcutt, unidentified, Ralph Northcutt, Lucille Northcutt, Glennis Hancock, Lotta Baldwin, Julie Daniel, and Emma Katherine Anderson; (third row) George Daniel, Ed Massey, Tom Brumby, Abe Fine, John Hancock, Lucius Atherton, and Charlie Brown; (fourth row) Ralph Hancock, Helen Brown, George Welsh, Ike White, Clyde Irving, Mac Hodges, Mac Fowler, Marvin Norton, Ralph Hibben, and Pierce Latimer; (fifth row) Pat Crowe and James T. Anderson. (James B. Glover V collection.)

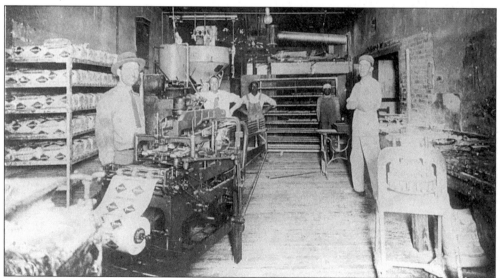

Sim Smith (right) and unidentified workers at Benson Bakery on Church Street are shown in 1918. The bakery operated in Marietta for about 25 years. (Mary Frances and Joel Anderson collection.)

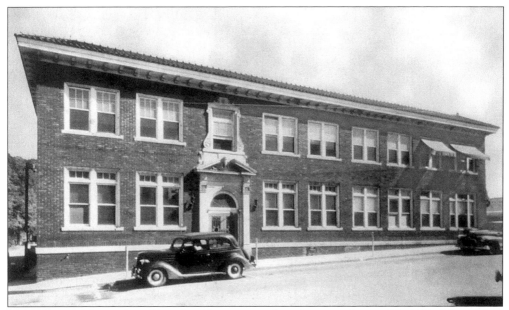

The Marietta Hospital on Cherokee Street opened its doors on August 23, 1928. The 50-bed facility served the community until 1950 when Kennestone opened. Among the first doctors listed as practicing at the hospital were George F. Hagood, C.D. Elder, W.H. Perkinson, William Kemp, and C.A. Donehoo. (H.C. Burnett Jr. collection.)

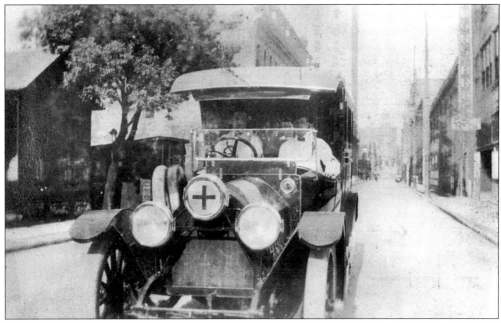

In this view of the downtown area, Kelly Bogle of Brumby Funeral Home drove an ambulance on the square in 1918. (Vanishing Georgia collection, Ga. Dept. of Archives and History.)

Marietta City Hall, located on Atlanta Street in this early 1900s picture, housed the city government from 1927 to 1979. Once a Masonic meeting house, the building was constructed in 1910. Prior to the city's purchase of the building, the mayor and city council held meetings in the Cobb County Courthouse. (Vanishing Georgia collection, Ga. Dept. of Archives and History.)

CITY of MARIETTA, COBB COUNTY, GA.

M _____

YOU ARE HEREBY COMMANDED, To be and appear at the Courthouse, in the City of Marietta, on the __23__ day of ____May____ 1914 at 7 o'clock A. M., with pick and shovel, to work the streets of said City Five Days or pay the sum of $2.50, being the commutation tax in lieu of street duty for said City. FAIL NOT UNDER PENALTY OF THE LAW.

John Awtrey, **E. P. Dobbs,**
CLERK. MAYOR

C. Yancey received the street work summons shown above from the City of Marietta in 1914. No records remain to tell if Mr. Yancey complied. The ordinance requiring this civic duty was repealed. (Ruth Anderson Northcutt collection.)

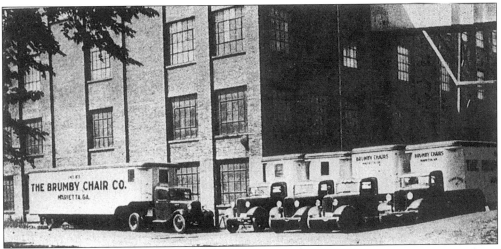

Seen here are Brumby Chair Company trucks parked at the factory on Kennesaw Avenue (now South Marietta Parkway) in the 1940s. Founded by James R. Brumby in 1874, the first factory burned shortly after it opened. Brumby rebuilt in 1878 at the present location of the Brumby Loft Apartments, formerly the chair company's building. The Brumby family still manufactures the famous "Brumby Rockers" with a store on the Marietta square. (Otis A. Brumby collection.)

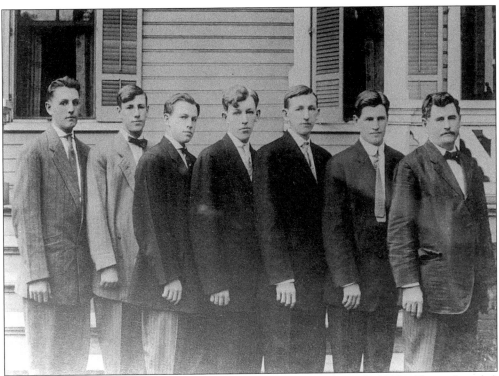

Thomas M. Brumby and his six sons posed for this picture in the early 1900s. Shown from left to right are: Thomas, William Magruder (Jack), Joe Bates, Otis Anoldus, James Remley, Robert Eldridge, and Thomas Micajah. (Otis A. Brumby collection.)

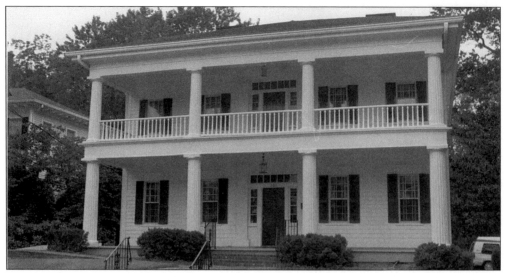

David Ardis was a south Georgia planter who brought his family for summer visits to Marietta. They liked the town so much they bought the two-story house across from First Presbyterian Church in the 1850s and became permanent residents. In 1864, while the Ardis family sought refuge in Alabama, Union troops burned all their outbuildings but the dwelling was spared. During a period in the 1930s, a notorious visitor, Virginia Hill, rented an apartment in the house on summer visits to her family. The building is now an insurance company's offices. (Photograph by Joe McTyre.)

In the 1930s, Virginia Hill, glamorous bit-part actress and girlfriend of Chicago mobsters, visited Marietta. Her visits caused quite a stir and helped the town's economy as Virginia spent lavishly from rolls of $100 bills. On one visit, she paid cash for a Buick convertible for her brothers. Virginia was the talk of the town when she rode about on a horse she kept specifically for her Marietta visits. (Bill Kinney collection.)

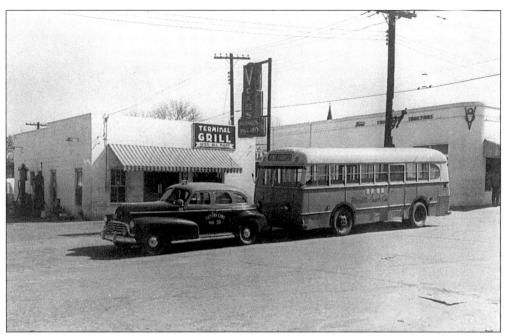

This early 1950s picture shows the city bus terminal and taxi stand located on Cherokee Street. A Victory Cab Company car and Marietta Coach Company bus appeared ready to take on passengers. (Marietta Museum of History Collection.)

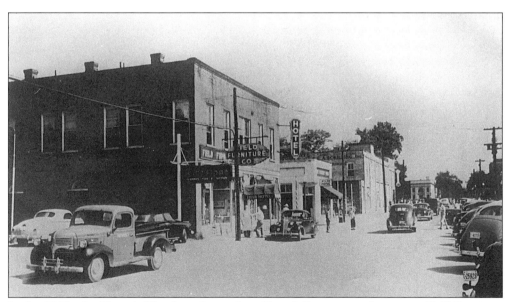

In the 1940s, the Georgia Hotel was located on Church Street near the square. Field Furniture shared the building with the hotel. This view looks south toward the main business section. (Marietta Museum of History Collection.)

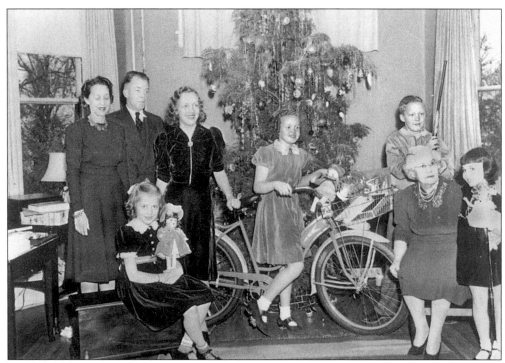

The L.M. Blair family celebrated Christmas at their home on Cherokee Street in the late 1930s. Pictured from left to right are: (front row) Anne Blair, Anne George Hudgens, and Connie Hudgens; (back row) June H. Blair, L.M. Blair, June, Barbara, and Dan Blair. (Renshaw collection.)

In 1928, the Bray family's lawn was featured in a magazine advertisement for Bermuda grass seed. Shown in front of their Church Street home are Columbus LaFayette Bray, his daughter, Jane, and a neighbor's dog, borrowed for the picture. The house, built by the Brays in 1925, still stands near Kennestone Hospital. (Jane Bray Awtrey Crisp collection.)

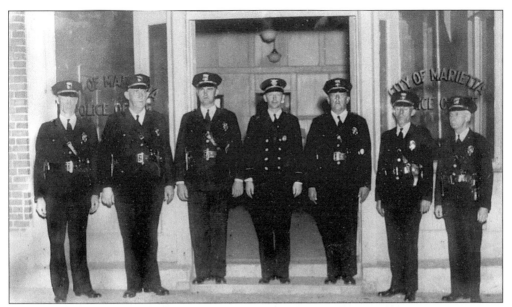

Marietta's entire police department posed for this picture in front of the Atlanta Street headquarters in 1938. This scene includes from left to right: unidentified, unidentified, Harold P. Griggs, Chief W.J. Black Jr., Harry Scoggins, unidentified, and Floyd Jolley. Griggs became department chief in 1939, and served until 1947 when he left police service. Ten years later, he joined the Cobb County Police Department and served as chief investigator until his retirement in 1964. (Gretchen Griggs Vaughan collection.)

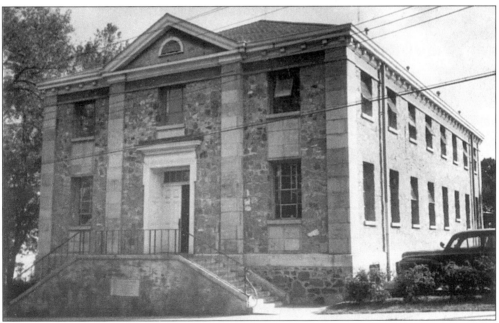

The Cobb County Building stood on Lawrence Street from the time of its construction by WPA workers in the 1930s to the 1960s when it was demolished. Among the offices occupying the building were the county agricultural extension agent and the Chamber of Commerce. (Vanishing Georgia collection, Ga. Dept. of Archives and History.)

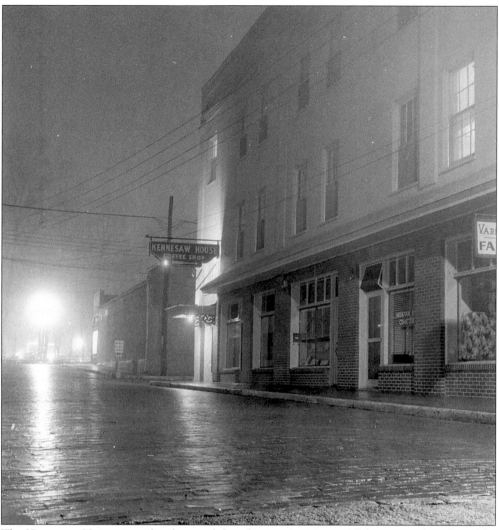

The Kennesaw House, once bustling with hotel guests arriving at all hours, appears ghost-like on a foggy night in the 1950s. Shops with separate entrances are no longer part of the historic building by the railroad. (Photograph by Joe McTyre.)

Five
WORLD WAR II AND PROSPERITY
1941–1960

Marietta experienced moderate growth after the Depression years, reaching a population of 8,600 in 1940. When the United States entered World War II, Marietta was selected by the federal government as the site for a huge B-29 manufacturing plant operated by Bell Aircraft Corporation. With newcomers pouring in to work in the factory, the city and the county experienced drastic change. Numerous new housing projects went up hurriedly to meet tremendous demands. For the third time, residents rallied to provide for those in military service. With the war's end, the "bomber plant" closed in 1946 but the Korean conflict spurred the government to reopen the factory in 1951, with Lockheed Aircraft Corporation operating it. Marietta's population had almost tripled in a decade. The company became Georgia's largest employer during the 1950s and 1960s, stimulating the once quaint, small town to plan for unprecedented growth. By 1960, Marietta had more than 25,500 residents.

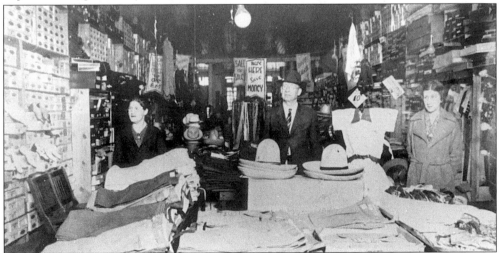

Longtime Marietta merchant Philip Goldstein and employees of Goldstein's Store on the square posed for this 1940s photograph. (Philip Goldstein collection.)

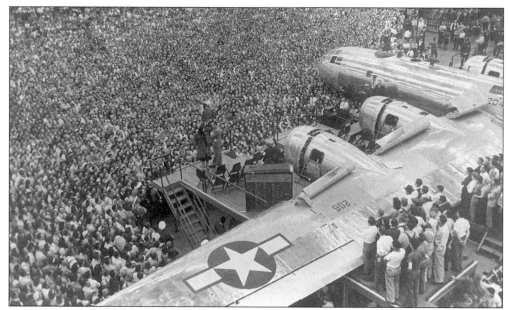

Bell Aircraft production workers turned out to hear comedian Bob Hope in an appearance at a war bond drive at the aircraft plant during World War II. Bell employees responded overwhelmingly and went over their quota in purchasing bonds for the sixth time. (Bill Kinney collection.)

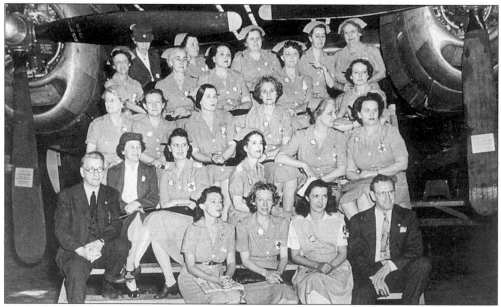

During World War II, Marietta women served as Red Cross volunteers, known as "Gray Ladies," at the Bell Aircraft plant. Pictured after a hangar tour with two Bell executives are, from left to right: (first row) all unidentified; (second row) Gladys Branson, Ida Clotfelter, Prilla Glover, Mary Neal, and Ruth Coryell; (third row) Marian Sinclair, Mae Morrill, Dot Edwards, and Dorothy Goodman; (fourth row) Anne Willingham, Bess Massey, unidentified, and unidentified; (fifth row) Sadie Gober Temple, Annette Dozier, Bess Coleman, Anna Whittaker, and unidentified. (James B. Glover IV collection.)

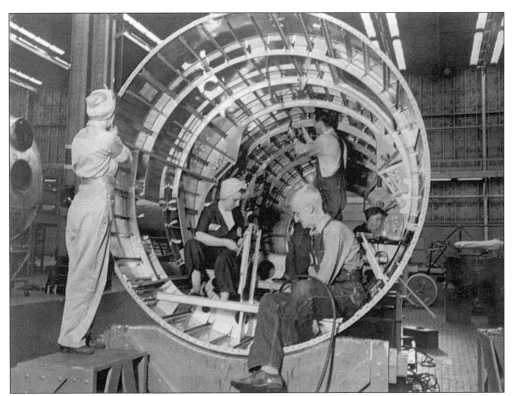

Bell Aircraft workers during World War II included women and older men, shown here working on a B-29, as staples of the production force. (Bill Kinney collection.)

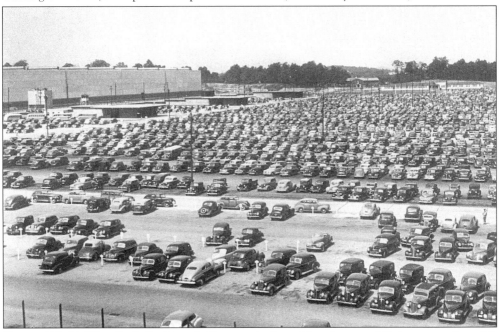

During World War II, Bell Aircraft Corporation's parking lot was filled to capacity with vehicles of all descriptions. (Bill Kinney collection.)

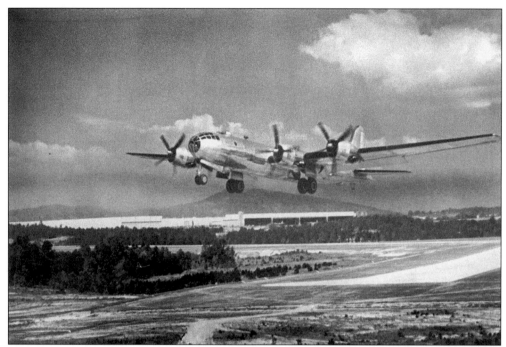

One of Bell Aircraft Corporation's giant B-29s is shown taking off from the Marietta plant's runway in the early 1940s. In the background are Kennesaw Mountain and the aircraft plant. From 1943, the year B-29 production began at the Marietta factory, to 1945, more than 600 bombers were built there. (Bill Kinney collection.)

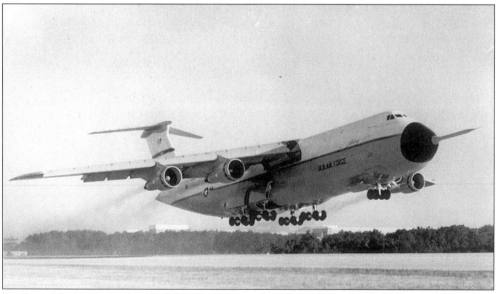

On June 30, 1968, the first C-5 lifted off for its first flight from the Dobbins Air Force Base runway. The C-5, the largest aircraft in the world at that time, was designed, built, and flown by Lockheed employees in only 32 months. More than 130 of the giant transports were built through the early 1990s. (Lockheed Martin collection.)

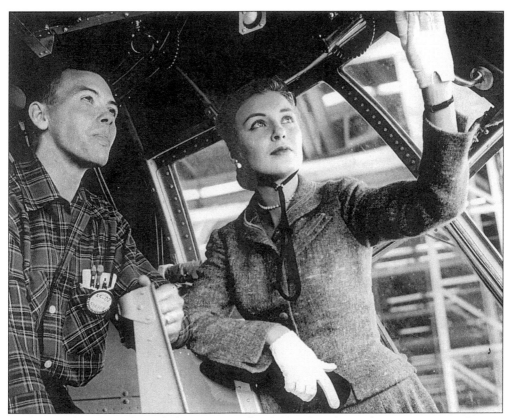

Wade Woodward III showed the interior of a C130 Hercules to his sister, actress Joanne Woodward, on the Lockheed assembly line where he worked in the late 1950s. Joanne still visits Marietta about once a year. (Wade Woodward collection.)

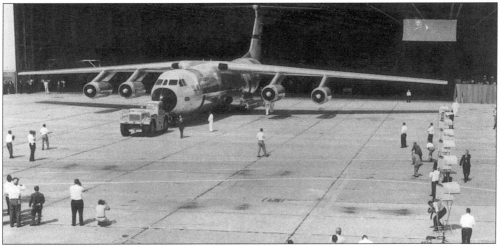

From the White House in Washington, D.C., on August 22, 1963, President John F. Kennedy addressed Lockheed-Georgia employees and dignitaries, and then electronically opened Lockheed's carnivorous hangar doors to unveil the nation's first fan-jet powered military cargo transport aircraft. During the late 1960s, 285 C-141As were designed and produced at the Marietta plant. (Lockheed Martin collection.)

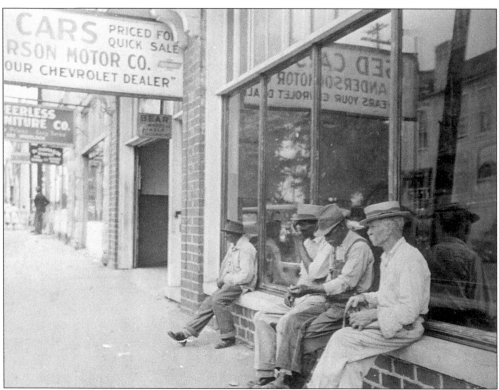

A typical Saturday afternoon in downtown Marietta drew shoppers and others just passing the time of day. This 1940s view includes men sitting in front of Anderson Motor Company on Powder Springs Street. (Bill Kinney collection.)

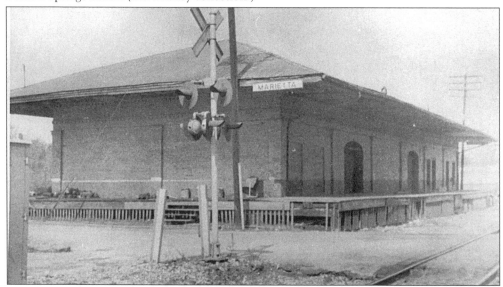

For almost 100 years, the rail freight depot shown here was the busy scene of loading and unloading for trains traveling through Marietta. The state-owned depot, built in the late 1800s, was damaged in a train wreck in 1974. Judging that the damage was too extensive for repairs, the state demolished the depot. (Marietta Museum of History collection.)

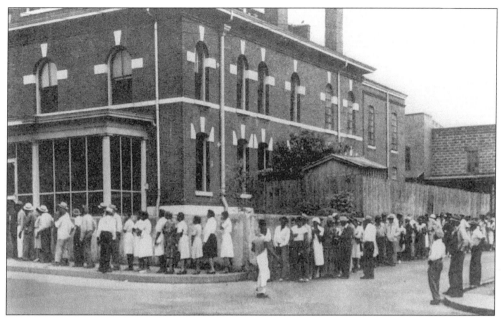

Black residents of Cobb County lined up around the courthouse and the county jail building to register to vote in 1946, after a court ruling which declared Georgia's all-white primary election illegal. (Hardy Studio collection.)

Cobb County Sheriff J. F. "Babe" Hicks is pictured in his office in the county jail on Washington Avenue during his term, which lasted from 1941 to 1944. (Mary Frances Smith Anderson collection.)

This scene includes students working on a project in shop class at Lemon Street High School in 1954. Pictured from left to right are: Charles Tiller, William Scott, George Kennebrew, instructor Joel Sadler, and James Dodd, now a Marietta city councilman. (Photo by Joe McTyre.)

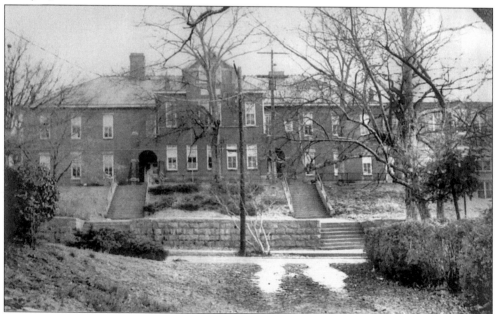

Waterman Street School, one of the Marietta schools Joanne Woodward attended while a city resident in the early 1940s, closed in the 1960s. All that remains are the front steps. (Hardy Studio collection.)

Larry Bell Auditorium was built in 1945 on Clay Street (now Highway 120 Loop) on the site of the former county convict camp. The building, named for Bell Aircraft President Lawrence (Larry) Bell, was constructed with federal and local funding. Bell left a $200,000 bequest to the facility that was used to build a garden and fountain in front. The auditorium burned in the mid-1960s. (Bill Kinney collection.)

In the mid-1900s, Marietta had four movie houses including the Bell Theater, shown in 1956. The theater was located at Fairground and Clay Streets, now the site of a service station. (Hardy Studio collection.)

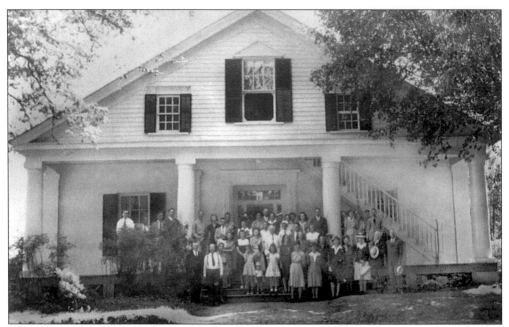

Organized in 1943 with 33 charter members, Roswell Street Baptist Church is now Marietta's largest church. The church purchased the Robeson Plantation house and grounds about a mile east of the square. The plantation buildings were built by J.B. Wallace on a 100-acre plot. The early worship services were held in the plantation house, shown here with church organizers. The church later razed the structure. (Roswell Street Baptist Church collection.)

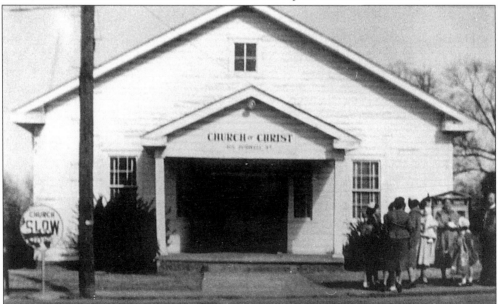

Organized in 1885 as the Liberty Hill Church and Meeting House, the congregation members built the building shown here on a Roswell Street lot purchased in 1940. The first service was held in the new building as the Roswell Street Church of Christ on July 28, 1940. Since 1994 the church has been located on Piedmont Road. The Roswell Street building is now attorneys' offices. (Yvonne Brand Heaton collection.)

Entrepreneur Sylvester "Shine" Fowler was nicknamed "Mayor of Lawrence Street" in the 1940s. He owned a pool room, beer parlor, and a taxi business on the northeast corner of the square. Shown with Fowler are (right) Ansley Little (now Mayor Ansley Meaders) and Neal Little. (Bill Kinney collection.)

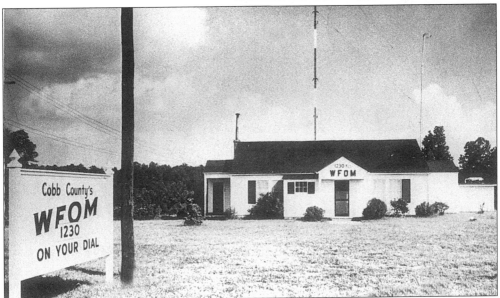

Marietta and Cobb County's first radio station, WFOM, went on the air about 1950. WFOM's first owner and general manager, Albert L. Jones, chose the slogan "Where Fortune Offers Most." The station's first location on South Cobb Drive is shown here. Originally the station had a community news format. Today, many changes later, WFOM broadcasts gospel music from its Atlanta studio. The tower is still located in Marietta. (Carolyn Amburn collection.)

Marietta High School junior and senior students are shown at their annual prom in 1946 at the Brumby gymnasium. The school's basketball games and other events were held in the gym for many years after its construction on the northwest corner of Winn and Polk Streets in 1938. The building was demolished in the 1980s during expansion of the high school. (J.B. Glover IV collection.)

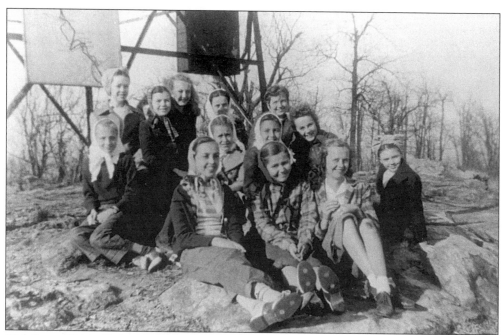

Girl Scout Troop 9, sponsored by First Methodist Church, Marietta, is seen here in 1945. Pictured from left to right are: (front row) Joyce Caldwell, Jane Hendry, and Ann Groover; (second row) Joyce Ann Loudermilk, Marjorie Abercrombie, Jo Ann Brinkley, and Barbara Lowery; (third row) Charlotte Turner, Barbara Smithweck, Patsy Ward, Helen Hadaway, and Emma Jane Marr. Leaders (not pictured) were Mae Dobbs Kincaide and Jessie Smithweck. (Amanda Canup collection.)

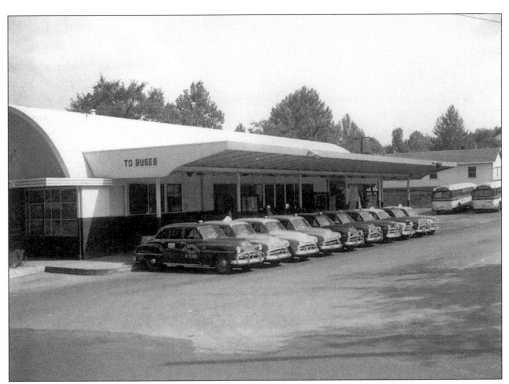

The Marietta Bus Depot, operated by the Greyhound Bus Company and once a familiar scene on Anderson Street, is pictured in 1954. The terminal was built in 1947 and relocated to U.S. 41 (Cobb Parkway at the 120 Loop) in the 1980s. After extensive alterations, the original terminal building and garage are now attorneys' offices. (Hardy Studio collection.)

Betty Welsh posed for this scene at the Peppo Ice Cream Shop on U.S. 41 in 1950. The store was located on the approximate site of the "Big Chicken." (Betty Welsh Williams collection.)

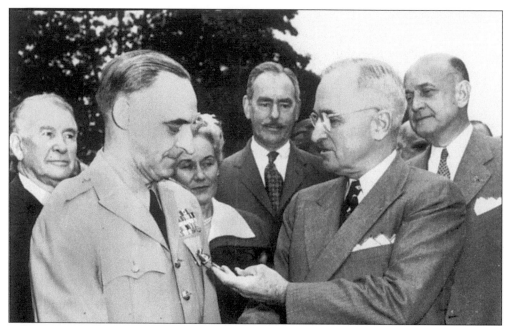

In 1949, President Harry S. Truman presented the Distinguished Service Medal to Gen. Lucius D. Clay, (1897–1978) a Marietta native, at the White House. Clay was decorated for his service as commander-in-chief of the European Command and military governor of Germany from 1945 to 1949. A Marietta High School and West Point graduate, Clay served 31 years in the army. After his military retirement, he was CEO of Continental Can Company and an adviser to President Dwight D. Eisenhower. (Bill Kinney collection.)

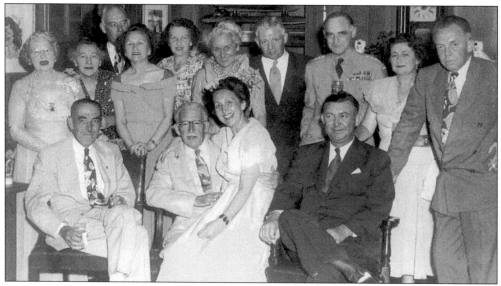

June and L.M. Blair hosted a party for Gen. and Mrs. Lucius Clay when they came to Marietta in 1949. Seated from left to right are: (front row) Arthur Crowe, ? Crawford, June Blair, and T.O. Branson; (middle row) Hallie Crawford, Edith Crowe, Gladys Branson, Louise McNeel, Marjorie Clay, Morgan McNeel, General Clay, Hazel McNeel, and L.M. Blair; (back row) Eugene McNeel. (Barbara Blair Renshaw collection.)

In this 1950s scene, Frank Spears is shown at his livery stable one block south of Whitlock Avenue near the railroad. Spears operated his business from the 1930s to about 1960. (Rose Spear Hill collection.)

This view of the Cherokee-Page Streets intersection in 1949 is vastly different from the present day. Now, the junction of North Marietta Parkway and Cherokee Street connects east-west traffic to Interstate 75. (Marietta Museum of History collection.)

The Strand Theater, the last of three downtown movie houses operating in Marietta, entertained generations of Marietta and Cobb residents. Built in the mid-1930s, the Strand's last movie ran in 1977 when the Goldstein family purchased it from the Georgia Theater Company. The owners have rented the building for use as a church and entertainment venues. Actress Joanne Woodward wrote city officials in 1989: "My entire childhood was spent in that theater and it's certainly one of the major reasons I became an actress." (Photo by Joe McTyre.)

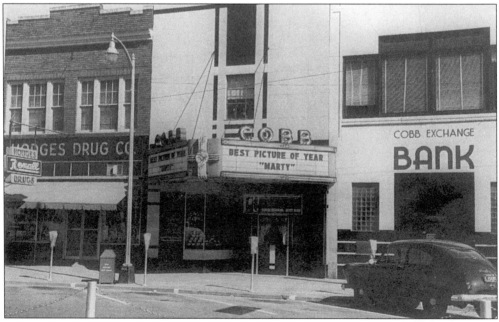

North Park Square was the location of three businesses that no longer exists. This early 1950s view shows Hodges Drug store, the Cobb Theater, and Cobb Exchange Bank. (Photo by Joe McTyre.)

Actress Joanne Woodward is pictured in 1958 receiving the Academy Award for best actress for her performance in "The Three Faces of Eve," released in 1957. Presenting the Oscar was actor John Wayne. A Marietta resident from 1937 to 1945, she attended Haynes Street Elementary, Waterman Street Junior High, Marietta High schools, and the First Presbyterian Church which her family joined. Born in Thomasville, Georgia, in 1930, Joanne and her brother, Wade Woodward, who still resides in Marietta, lived with their parents in the house they built on Freyer Drive. (Wade Woodward III collection.)

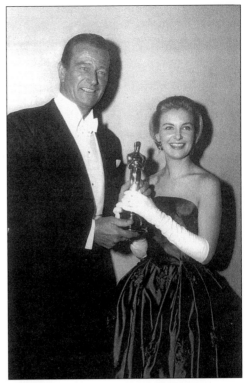

Joanne Woodward spoke to Marietta Kiwanis Club members in 1958, the year the popular Hollywood actress won an Oscar for her performance in "The Three Faces of Eve." Looking on from left to right are: unidentified, Dan Fletcher, Truman Fletcher, and B.C. Yates. (Bill Kinney collection.)

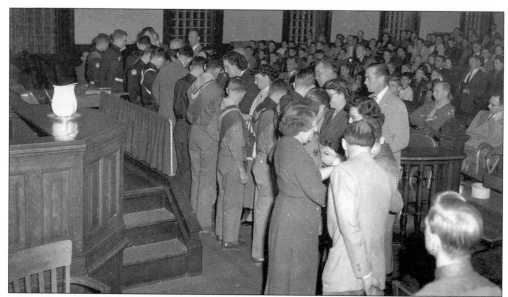

The courtroom of Cobb County's 1872 courthouse was the scene of many community gatherings similar to the Eagle Scout ceremony in 1953 shown here. Parents stood with their sons and pinned on their badges in front of a large crowd. The court building was demolished in 1969. (Photograph by Joe McTyre.)

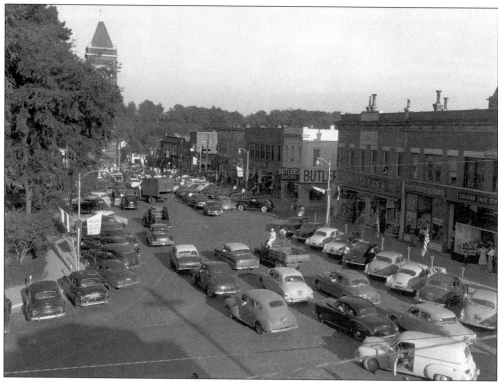

In this scene, the photographer's vantage point gives a good overview of the Marietta square, looking south toward the courthouse in 1953. (Photograph by Joe McTyre.)

Marietta residents M.W. Kinney and Regina Rambo Benson were among passengers disembarking from the last streetcar running between Marietta and Atlanta in 1947. (Bill Kinney collection.)

Marietta Daily Journal reporter Bill Kinney is pictured in the newspaper office on Anderson Street in the 1950s. Kinney, who has worked for the newspaper for 59 years, is the associate editor and writes one of the most widely read columns in the Atlanta area. He has received numerous awards from the Georgia Press Association and was named Cobb County's Citizen of the Year. (Photo by Joe McTyre.)

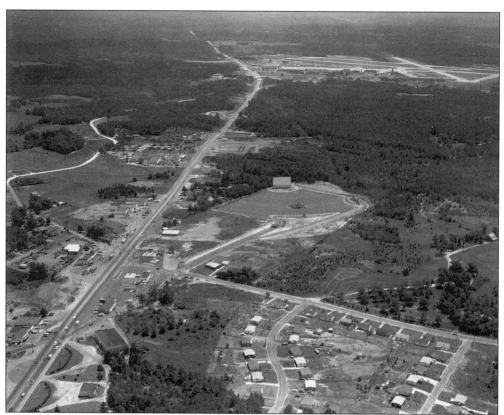

In this 1953 aerial view of the intersection of U.S. Highway 41 (Cobb Parkway) and Clay Street (now South Marietta Parkway), Dobbins Air Force Base and the Georgia Drive-in Theater are also visible. (Photo by Joe McTyre.)

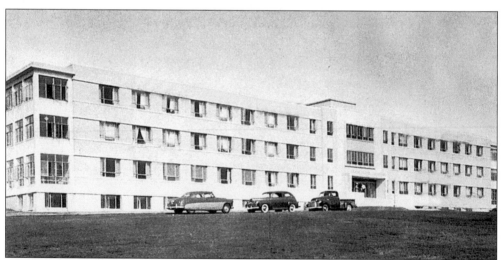

In 1950, the community celebrated the opening of the new Kennestone Hospital on Church Street. Named for Kennesaw and Stone Mountains, the new health facility had 105 beds and 24 bassinets. Construction cost was about $1.2 million. (Amanda Canup collection.)

In this 1958 picture of Marietta High School, the Antley Building and the Fine Arts Building are shown beyond the Birney Memorial Garden on Winn Street. (Photo by Joe McTyre.)

For several decades, Marietta High School's Friday night football games have been a community event, drawing citizens of all ages to cheer the home team. This 1957 scene includes Dr. Tony Musarra (left) and Romeo Hudgins taking care of an injured player. Marietta Coach French Johnson is standing in the background. (Photo by Joe McTyre.)

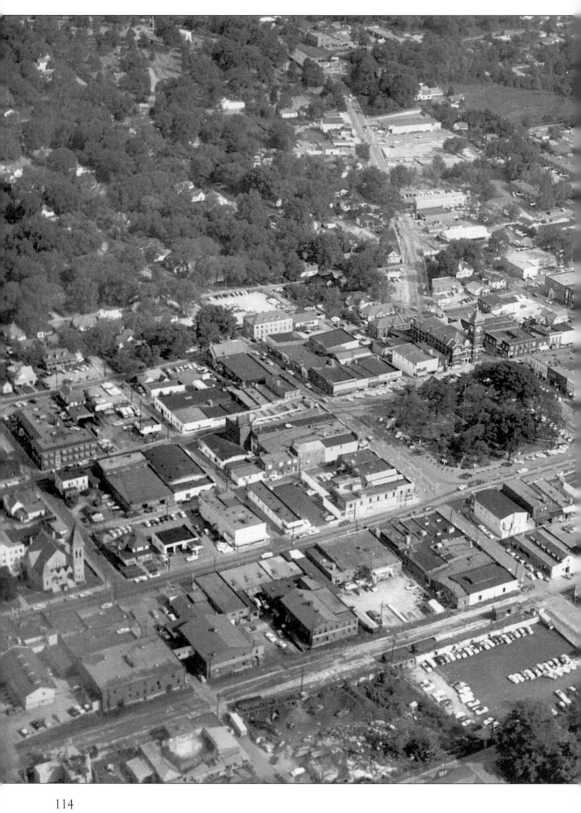

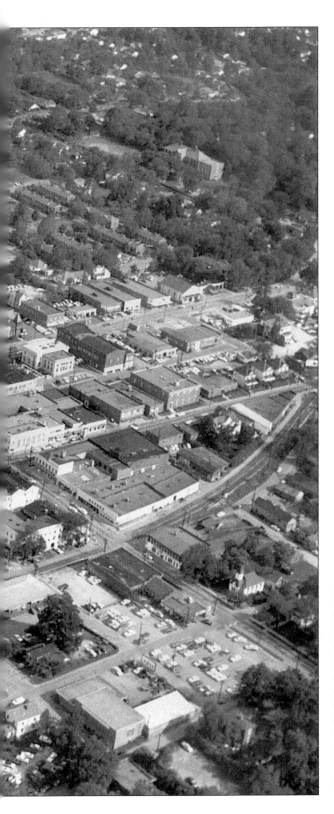

An aerial photograph of downtown Marietta, taken in 1953, shows the city from the Marietta Hospital on the north to Waverly Way on the south side. On the top part of the picture is the Coca-Cola plant on Roswell Street and Whitlock Avenue, three blocks west of the square. Marietta in the 1950s had a small town atmosphere embodied by the historic Cobb County courthouse, small locally owned businesses, and large hardwood trees shading Glover Park. (Photograph by Joe McTyre.)

One of Marietta's best known landmarks is the "Big Chicken" on North Cobb Parkway. In 1963, S.R. "Tubby" Davis had the original 56-foot-high bird built to publicize his fried chicken restaurant, the Chick, Chuck and Shake. After high winds damaged the sheet metal fowl in 1993, more than 10,000 Marietta area residents voted on the design of the rebuilt Big Chicken. Current owner Kentucky Fried Chicken spent about $700,000 to rebuild the famous fowl and remodel its perch. The red and white bird is a marker signaling pilots to begin their approach to Atlanta and a landmark for military planes headed into Dobbins Air Reserve Base nearby. (Photo by Joe McTyre.)

Six

DEVELOPMENT BOOM

1960–2000

Enormous growth in the Marietta area during World War II and post-war decades has been dwarfed by a phenomenal boom in housing, industry, and business during the 1980s and 1990s. Hundreds of residential areas and subdivisions have developed all over the city and county, while large new shopping malls, restaurants, and support services have burgeoned to cater to new residents. The establishment of colleges and universities has helped spur growth. Southern Polytechnic State University, Kennesaw State University, Life University, Chattahoochee Technical Institute, and North Metro Tech all add to the quality of life. Also contributing to the area's progress is the interstate highway system with four major arteries providing access to jobs as well as drawing visitors to historic sites and other attractions. After older businesses in Marietta's downtown declined, the city launched a successful revitalization program in the 1970s, spearheaded by the Downtown Marietta Development Authority. Despite the loss of the 1872 Cobb Courthouse and adjacent stores (razed in 1969 to build a modern county government center), most buildings around the square have been refurbished and draw throngs of theater-goers, shoppers, and diners to the area. Preservation organizations are encouraging adaptive use of historic houses and buildings, and adoption of a historic preservation ordinance for Marietta—a city with five National Register of Historic Places districts. Today, Marietta's population is close to 50,000, in a county of a half-million-plus residents. The city operates its own independent school system and utilities including electricity, water, gas, and fiber optics. A thriving Marietta contains 21.6 square miles, 13,850 land acres, and anchors a strong sense of community identity for the county as a whole. [20]

The Marietta Conference Center and Resort on Powder Springs Street was built in 1996 by the city of Marietta on the site of the Georgia Military Institute. The hotel's facilities include 200 guest rooms, a pub and dining room, swimming pool, tennis courts, and golf. (Photo by George Clark.)

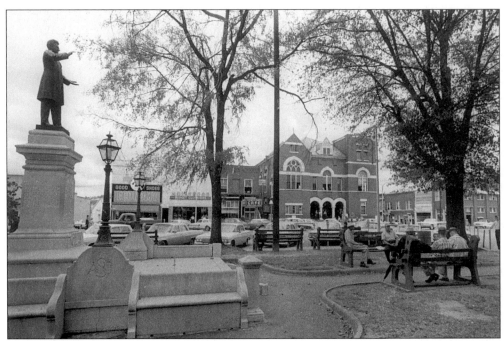

In this 1964 scene, the statue of Alexander Stephens Clay is pictured in its original location in Glover Park. Clay is the only Cobb Countian honored with a statue erected in his honor and the only citizen elected to the U.S. Senate from Cobb County. (Photo by Joe McTyre.)

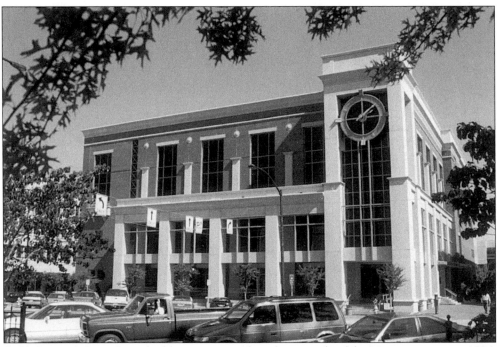

Cobb County's State Court building was erected on the east side of the Marietta square in 1996. Several shops and a popular restaurant were located on the site through the 1960s. (Photo by Joe McTyre.)

Kennesaw Mountain National Battlefield Park was built in the 1930s by Civil Conservation Corps workers. The visitors center and museum, built in 1964 near the mountain, was enlarged in 1999. Park visitors number about 1.2 million annually. (Photo by Joe McTyre.)

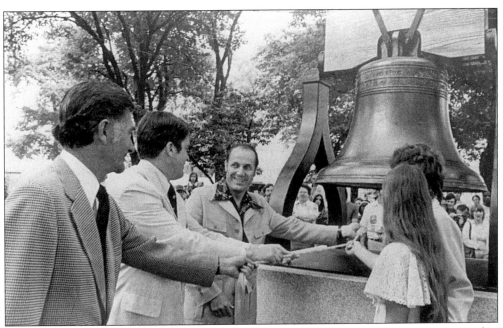

Dedication of the Liberty Bell now displayed in Glover Park was one of the events organized in celebration of the nation's bicentennial in 1976. Pictured in this scene from left to right are: Cobb Commission Chairman Ernest Barrett, 7th District Congressman Larry McDonald, and Marietta Mayor Dana Eastham. The bell is a reproduction of the original Liberty Bell in Philadelphia. (Bill Kinney collection.)

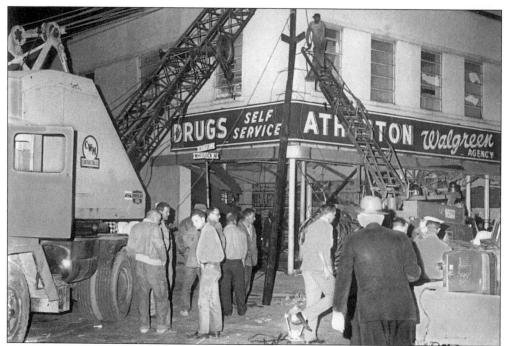

With hundreds of Mariettans on the square for a Halloween night carnival in 1963, an explosion rocked the area, destroying Atherton Drugs and piling debris onto the square. The blast, caused by a natural gas leak, killed 7 adults and injured 23 others. These photos by the late Leslie Blair, *Marietta Daily Journal* photographer, were made within minutes of the explosion. Blair had just sat down at a booth inside the drug store and ordered a sandwich and a milkshake when the tragedy occurred. (Betty Blair Gosling collection.)

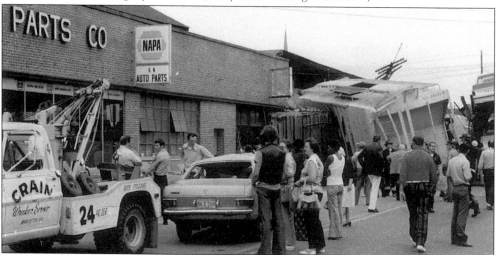

Marietta's freight rail depot was badly damaged in May 1974 when 11 boxcars of an L&N train jumped the tracks, plunged into the air, and crashed into the building. The train wreck also tore up railroad tracks and damaged the BN Auto Parts building and cars parked along the tracks. Two people were injured. The state-owned depot, leased to L&N at the time of the wreck, was built in the late 1800s. After judging that the damage was too extensive for repairs, the state demolished the depot. (Marietta Museum of History collection.)

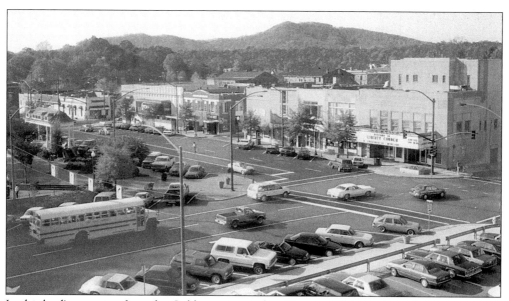

In this bird's-eye view from the Cobb court complex, Kennesaw Mountain makes a picturesque background to the city's North Park Square in 1991. (Photo by Joe McTyre.)

Victoria Franklin Chastain was the first woman elected mayor of Marietta. She served from 1986 to 1989 after two terms as a city councilwoman. A Marietta native, she received many community awards, was president of the Cobb Municipal Association, and a member of many governmental and civic associations. She is CEO of Chastain and Associates, a real estate development and property management company in Marietta.

The Marietta City Cemetery is the final resting place of Mary Phagan, a young girl born in Marietta, who was assaulted and murdered in the Atlanta pencil factory where she worked in 1913. Mary was a 14-year-old Atlanta resident at the time of her death. Her tombstone was provided by the Marietta Camp No. 763, United Confederate Veterans. (Above: Joe McTyre collection; below: Photograph by Joe McTyre.)

Six-year-old JonBenet Ramsey, like Mary Phagan, died under bizarre circumstances. The young girl was found by her father, murdered in her home in Boulder, Colorado, in December 1996. JonBenet, pictured in a beauty contest photo, is buried in St. James Cemetery in Marietta. Her death is currently under investigation. (Above: Marietta Daily Journal Collection; below: Photograph by Joe McTyre.)

Georgia Gov. Roy Barnes, inaugurated in January 1999, practiced law in Marietta from 1975 to 1998. He is shown in his office on Anderson Street in 1995. Barnes, a native Cobb Countian, served 20 years in the state legislature as a senator and representative. He is a graduate of Cobb County public schools and received undergraduate and law degrees from the University of Georgia. (Photo by Joe McTyre.)

A young Marietta family is pictured at their restored 1907 Maple Avenue home. Shown are Dr. Scott Mills, holding Logan, and Carla Mills with children (left to right) Brigham, Joshua, and Emma. (Photo by Joe McTyre.)

Georgia Supreme Court Justice George T. Smith administered the oath of office as Marietta mayor to Joe Mack Wilson (1919–1993) on January 2, 1990. Wilson served 27 years in the state house of representatives, the longest serving member of Cobb County's delegation. (Photo by Joe McTyre.)

About 40,000 people saw the start of the History Channel's Great Race on the Marietta Square on June 6, 1999. In this scene, Marietta Museum director Dan Cox portrayed a long-ago Marietta mayor and 100 vintage automobiles started their race from Marietta to Anaheim, California. The Marietta Welcome Center and Visitors Bureau and the city of Marietta planned the weekend festival. Marietta's economic impact from the Great Race was $1.2 million—it was one of the largest events to take place in the area. (Marietta Welcome Center and Visitors Bureau collection.)

Preston Harris Hines of Marietta was appointed to the Georgia Supreme Court in 1995. Born in Atlanta in 1943, he practiced law in Marietta and served as a judge of the Cobb County State and Superior Courts. Members of the 1999 Georgia Supreme Court, pictured above from left to right, are: (seated) Presiding Justice Norman S. Fletcher, Chief Justice Robert Benham, and Justice Leah Ward Sears; (standing) Justice Hugh P. Thompson, Justice Carol W. Hunstein, Justice George H. Carley, and Justice P. Harris Hines. (Harris Hines collection.)

Marietta resident George Conley Ingram was named to the state supreme court in 1973. Born in Dublin, Georgia, in 1930, he practiced law in Marietta and served as a Cobb County Superior and Juvenile Court judge. In 1977, Ingram left the high court bench. He worked as a special assistant attorney general from 1979 to 1986 and returned to private law practice. He is a senior judge for the state of Georgia. (G. Conley Ingram collection.)

John Harold Hawkins of Marietta served from 1948 to 1960 on the Georgia Supreme Court. Hawkins (1892–1961) attended Marietta public schools and was admitted to the bar in 1916. He practiced law in Marietta from 1920 to 1931, was a circuit judge from 1931 to 1948, and was elected a Supreme Court associate justice in 1948. Shown above, Justice Hawkins is seated on the far right. (Vanishing Georgia collection, Ga. Dept. of Archives and History.)

Retired Supreme Court Presiding Justice George T. Smith is the only person in Georgia history to win contested elections in all three branches of state government. A Mitchell County native, he practices law and resides in Marietta. He graduated from the University of Georgia School of Law and was a state representative and Speaker of the House in the 1950s. He was elected lieutenant governor in 1966 and, a decade later, won a term as state Court of Appeals judge. He was elected to the Georgia Supreme Court and served from 1981 to 1991. (George T. Smith collection.)

Endnotes

1 Sarah Blackwell Gober Temple, *The First Hundred Years—A Short History of Cobb County in Georgia* (Marietta: Cobb Landmarks and Historical Society Inc., 1989).
2 Philip L. Secrist, Historic Cobb County Bicentennial Project: *Historical Inventory of Marietta and Cobb County* (Marietta, 1976).
3 Bowling C. Yates, *Historic Highlights in Cobb County* (Marietta, 1973).
4 Temple.
5 Robert Manson Myers, *The Children of Pride* (New Haven and London: Yale University Press, 1984).
6 William King, *Diary of William King, Cobb County, Georgia, July 2 to September 9, 1864*, (Marietta: 1864).
7 Ibid.
8 Temple.
9 Franklin M. Garrett, *Atlanta and Environs—A Chronicle of Its People and Events, Vol. I and Vol II*, (Athens: University of Georgia Press, 1988).
10 Temple.
11 Ibid.
12 David Cullison, *Historic Resources Survey of the City of Marietta, Georgia* (Marietta: Department of Development and Planning, 1993–1994).
13 Dr. Thomas A. Scott, "*A Century and a Half of Marietta History*," Marietta Welcome Center—Walking/Driving Tour (Marietta, 1984).
14 Ibid.
15 Cullison.
16 Ibid.
17 Temple.
18 Ibid.
19 Ibid.
20 Scott.

Sources

Ruth Wagner Miller, *First Family Memoirs—A 150-Year History of First Baptist Church, Marietta, 1835–1985* (Marietta: First Baptist Church 1985).
Henry Higgins and Connie Cox, ed. with Jean Cole Anderson, *Journal of a Landlady—Louisa Warren Fletcher* (Chapel Hill: Professional Press, 1995).
Joan Alice Kopp with Scott Grady Bowden, *Sarah Freeman Clarke, 1808–1896, A Woman of the Nineteenth Century* (Marietta: Cobb Landmarks and Historical Society, 1993).
Marietta Daily Journal, Otis A. Brumby, Publisher, Marietta, Georgia.
Lucrete M. Hammons and Betty Carr, *A Higher Obligation: The Story of First United Methodist Church of Marietta, Georgia* (Marietta: First Methodist Church, 1983).
History of St. James Church, Marietta, Georgia (Marietta: St. James Church, 1994).
A History of the First Presbyterian Church, Marietta, Georgia (Marietta: First Presbyterian Church, 1976).
Mary E. Martin, *A History of St. Joseph's Catholic Church, Marietta, Georgia* (Marietta: St. Joseph's Church, 1977).
Roger Hines and Donna Rypel, *A Glorious Past—A Glorious Future, 1943—1993* (Marietta: Roswell Street Baptist Church, 1993).